T0279384

POSTCARD HISTORY SERIES

Jekyll Island

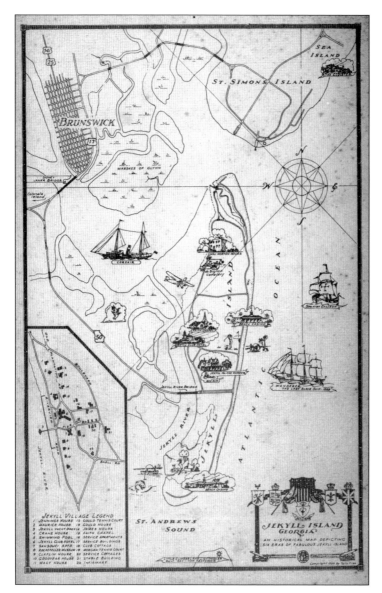

This 1950s map of Jekyll Island shows the basic layout of the island and highlights some of the more well-known sights and historic locations. On the lower left side of the card is a more detailed map of the historic district that identifies the placement of many of the club cottages and significant buildings. The map also shows the island's proximity to neighboring St. Simons Island to the north and the city of Brunswick, Georgia. (Courtesy of Mosaic, Jekyll Island Museum.)

ON THE FRONT COVER: The construction of the stately clubhouse on Jekyll Island was not an easy task for 60-year-old architect Charles A. Alexander. Issues with building material shortages, unskilled local workers, and an inept head contractor compelled the Chicago-based designer to take over all aspects of the project. The result became one of his finest accomplishments. Unfortunately, it would also be the last of Alexander's projects that he saw to completion, as he died in May 1888, just six months after the clubhouse was finished. (Courtesy of the author.)

ON THE BACK COVER: Faith Chapel (pictured) was built in 1904 to replace the much smaller Union Chapel, the club's first church building. Constructed in the late 1890s, Union Chapel had a simple design without any of the ornate features of its successor. Once it was in use by the club, it became evident that the club would need a larger space. In 1903, in order to make way for the construction of Faith Chapel, the smaller Union Chapel was relocated to an area of the grounds known as the Quarters and was used by the black workers of the club as their place of worship. (Courtesy of the author.)

POSTCARD HISTORY SERIES

Jekyll Island

Michael M. Bowden and Robert M. Bowden

ARCADIA
PUBLISHING

Published by Arcadia Publishing
Charleston, South Carolina

Printed in the United States of America

Library of Congress Control Number: 2023930778

For all general information contact Arcadia Publishing at:
Telephone 843-853-2070
Fax 843-853-0044
E-mail sales@arcadiapublishing.com
For customer service and orders:
Toll-Free 1-888-313-2665

Visit us on the Internet at www.arcadiapublishing.com

*Dedicated to Scout and Sully, without whom this book would
have been completed in half the time.*

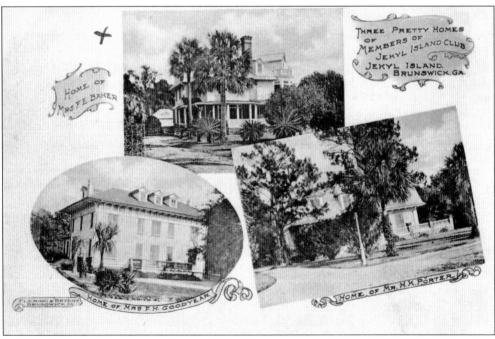

This tri-photo postcard features three of the Jekyll Island Club's member's cottages—Goodyear
Cottage (left), Mistletoe Cottage (right), and Solterra (top). While there is no exact date on this
postcard, it must be from before 1914, which is the year that Solterra, the home of Frances Baker,
burned to the ground.

CONTENTS

ACKNOWLEDGMENTS

I wish to thank the following people for their contributions to this project:

Bill Chappell
Tallu Fish
Bob Glander
Andrea Marroquin
C.L. Marsh
Van Jones Martin
C.H. Ruth
Amanda Spell
Don West

Unless otherwise noted, all images appear courtesy of the author.

INTRODUCTION

When postcards first made their way to the United States in the 1860s, they were mainly used as a less expensive way to send brief messages to friends and family. Because they did not require an envelope and consisted of a single small piece of paper, the postage was much less than that of a traditional letter. Although broad acceptance was not immediate due to their lack of privacy, postcards quickly became a popular form of informal communication.

Since the first postcards were not necessarily associated with travel or intended to reflect the location where they were purchased, they often did not include any sort of picture or image. They normally had advertisements or printed designs on one side and a space for the address on the other. By the late 1890s, picture postcards began to increase in popularity and quickly took the nation by storm. It was not long before every city and popular destination was printing and selling their own picture postcards as a form of promotion and advertisement. Their popularity continued to increase throughout the 20th century, and they are still widely used today despite the decline of written correspondence.

For the vendor, the postcard is a great way to promote whatever it is they represent. It could showcase some popular form of local entertainment, a beautiful nature scene, or a historic building. Many hotels also printed their own postcards to provide to guests for easy advertisement. Whatever the case, they are specifically designed with the intent to draw a person to that place. For the sender, it can be more personal. People use postcards not just as a form of quick and easy communication but as a way to help tell the story of their travels and adventures. We take time to browse through the cards on the rack and carefully pick out the one with an image that most closely represents our individual experience. As we travel from place to place, we pick out more and more postcards and drop them in the mail. By the time we get home, the loved ones who receive our postcards feel as if they were along for the ride the whole time. Postcards also offer a great way to keep records and memories of all the places we visit.

With the history of postcards in the United States dating back well over 100 years, they have also become a wonderful way to bring the nation's history to life. Some early postcards offer images of America that otherwise may not have been photographed or filmed. Thanks to the widespread popularity of postcards, there are very few places in America without historical postcards that help represent what life was like in that specific area over the past century. Sometimes, it may take a lot of searching and digging to find those earlier postcards, but is that not what makes postcard collecting so much fun? One never knows what they might discover.

When we, the authors, first started collecting Jekyll Island postcards, it was not just about picking out the images we liked the best or the cards that had the most interesting content, it was about piecing

together the most complete photographic history of Jekyll Island from the club era (1886–1946) through the state park era (1947–present). The fact that they were postcards—meaning they were physically used and handled by the people who lived the history of one of our favorite places—only made it more interesting. There is often something more personal about a postcard than an image or photograph that was put in a collection or printed in a publication. It feels much closer to the actual history, almost a part of the history itself. For us, that has always been the fundamental draw.

With this book, we hope to give people a glimpse into the past and help bring to life the story of Jekyll Island. With such a rich and complex history, you will undoubtedly learn something from this book that you did not know before. I know we learned a great deal from writing it and piecing it together. It was truly a labor of love, and we sincerely hope you enjoy the book as much as we enjoyed creating it. Next time you go to Jekyll Island, consider taking this book along. It can be quite amazing to stand in the exact spots these photographs were taken and see just how much—or how little—Jekyll Island has changed.

One

An Early History
Before the Club

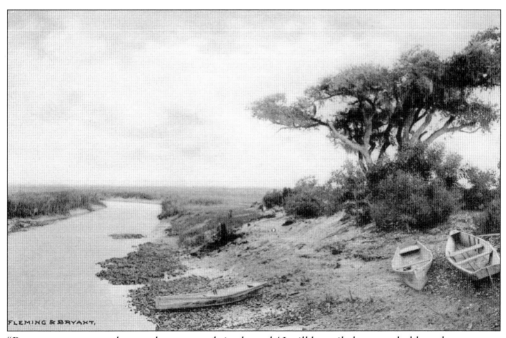

"By so many roots as the marsh-grass sends in the sod / I will heartily lay me a-hold on the greatness of God: / Oh, like to the greatness of God is the greatness within / The range of the marshes, the liberal marshes of Glynn" wrote Sydney Lanier in "The Marshes of Glynn."

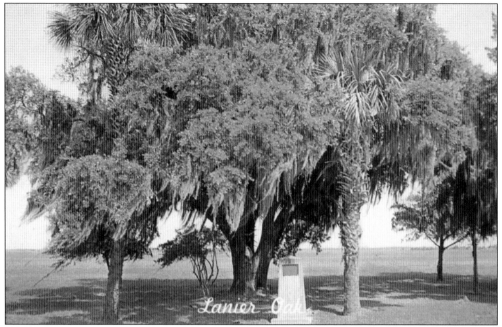

In the 1870s, underneath the moss-laden branches of this southern live oak tree, Sydney Lanier immortalized the salt marshes of Glynn County, Georgia, in his poem "The Marshes of Glynn." A small roadside park and plaque memorialize the old oak's location on US Highway 17 in Brunswick, Georgia.

Archeologists have determined that Jekyll Island was likely first inhabited by Native Americans roughly 3,500 years ago. Based on the artifacts found on the island, it is thought that they used the island primarily as hunting and fishing grounds.

Jekyll Island has long been treasured for its natural beauty and abundant wildlife. Although it is a relatively small island, measuring only about 5,500 acres in total, Jekyll Island's ecological diversity is quite impressive. Its maritime forests, salt marshes, and freshwater ponds are home to many rare species of plants and animals.

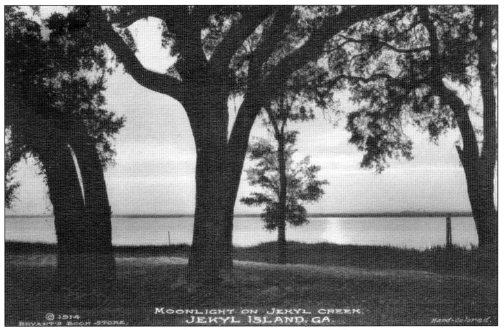

Anyone who gets the chance to soak in a glorious sunset over Jekyll Creek or stand on Driftwood Beach and watch the sun slowly rise through the ghostly branches can immediately understand why this island has drawn people to its shores for centuries.

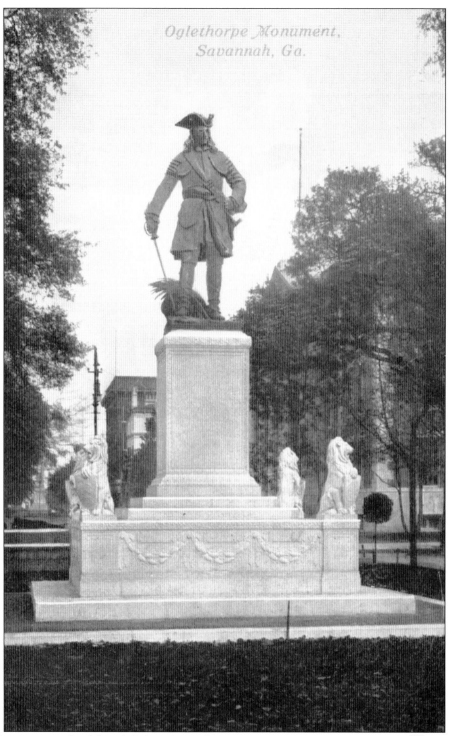

Oglethorpe Monument,
Savannah, Ga.

In the 1730s, England founded the colony of Georgia—the last of the 13 original colonies. Gen. James Edward Oglethorpe, a former British Army officer, played an instrumental role in the creation of the province and also in the establishment of the first English settlement on Jekyll Island.

The colony of Georgia was situated directly between Spanish-held Florida and the English stronghold of South Carolina. Gen. James Oglethorpe used Fort Frederica on St. Simons Island as a point of defense against an invasion by the Spanish. Today, people can visit Fort Frederica National Monument, pictured in this vintage postcard, and walk through what remains of the old coastal stronghold.

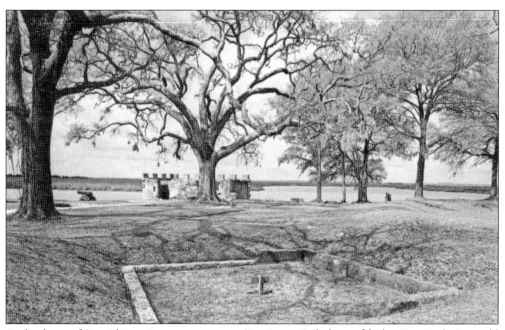

As the threat of Spanish invasion grew stronger, Gen. James Oglethorpe felt that Fort Frederica could benefit from additional defenses of its own. Jekyll Island, St. Simons Island's closest neighbor to the south, was the obvious choice for a new military outpost to serve that purpose.

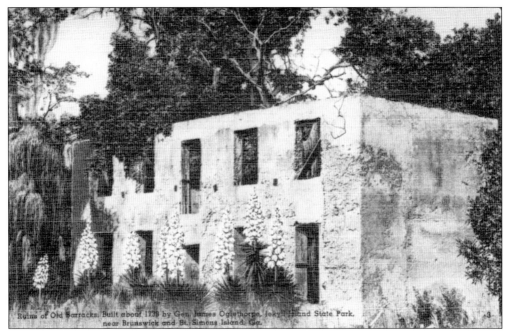

Gen. James Oglethorpe assigned the task of setting up a military outpost on Jekyll Island to Maj. William Horton, one of his top aides. Major Horton's first house on the island, built in 1736, was burned during an invasion by the Spanish just six years after it was constructed. It was replaced by the structure that still stands today thanks to the repair and preservation work financed by the members of the Jekyll Island Club in 1898.

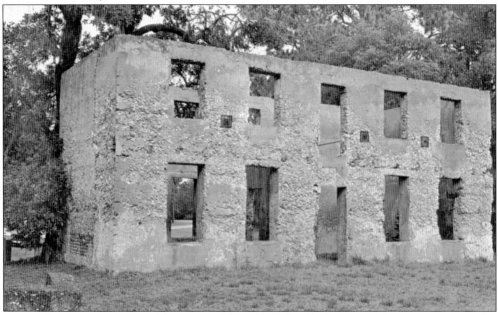

Maj. William Horton's second home on Jekyll Island, locally known as the Horton house, was constructed using tabby—a concrete made from a mixture of lime, sand, ash, and broken oyster shells. The structure is one of oldest surviving buildings in Georgia and is listed in the National Register of Historic Places.

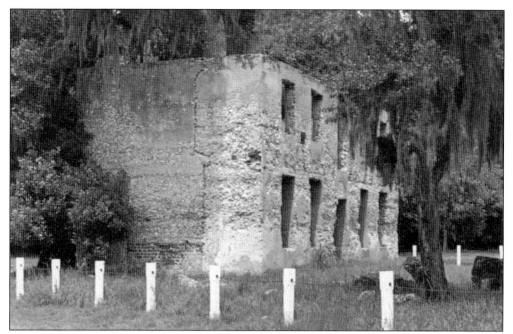

By 1800, Christophe Poulain du Bignon had become the sole owner of Jekyll Island. He and his family made the Horton house their home for many years while running a successful cotton plantation on the island. The du Bignon family maintained ownership of the island until it was sold to the founders of the Jekyll Island Club in 1886.

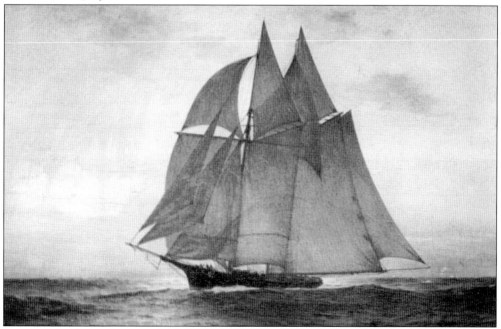

Originally built as a pleasure schooner in 1857, the *Wanderer* was one of the last ships to bring slaves to the United States from Africa. It landed at Jekyll Island on November 28, 1858, carrying 409 Africans who were kidnapped and forced to board the ship near the Congo. Members of the du Bignon family were brought to trial for their involvement in the illegal slave trade but were later acquitted.

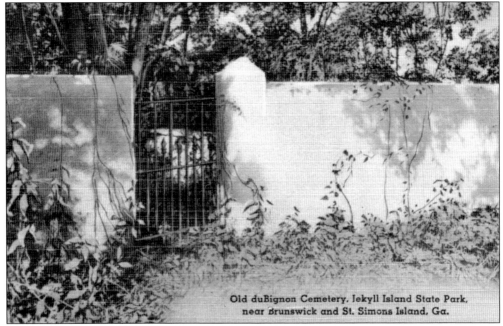

Old duBignon Cemetery, Jekyll Island State Park,
near Brunswick and St. Simons Island, Ga.

Just across the road from the Horton house is the old du Bignon family cemetery. Within its tabby walls lie three members of the du Bignon family and two employees of the Jekyll Island Club. Christophe du Bignon is believed to be buried on the grounds surrounding the Horton house, but the exact location of his final resting place is unknown.

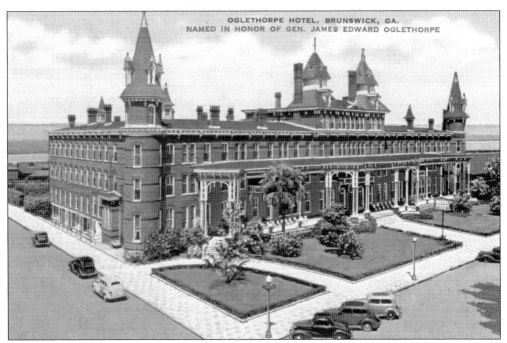

OGLETHORPE HOTEL, BRUNSWICK, GA.
NAMED IN HONOR OF GEN. JAMES EDWARD OGLETHORPE

The Oglethorpe Hotel, located in nearby Brunswick, was named in honor of Gen. James Oglethorpe. It officially opened in 1888 and was frequented by Jekyll Island Club members on their way to and from Jekyll Island. Unfortunately, the luxurious hotel was demolished in 1958 due to a lack of funding.

Two

THE CLUBHOUSE
THE JEKYLL ISLAND CLUB ERA

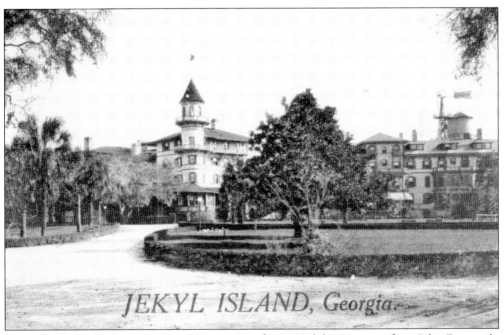

JEKYL ISLAND, Georgia.

In 1886, Jekyll Island was purchased by a group of New York businessmen from John Eugene du Bignon for approximately $125,000 for the purpose of creating an elite hunting and recreation club for some of the wealthiest men in the world. The beautiful clubhouse and grounds that were thoughtfully designed and expertly fabricated to serve the needs of the Jekyll Island Club have since become a beloved jewel of the southern Georgia coast.

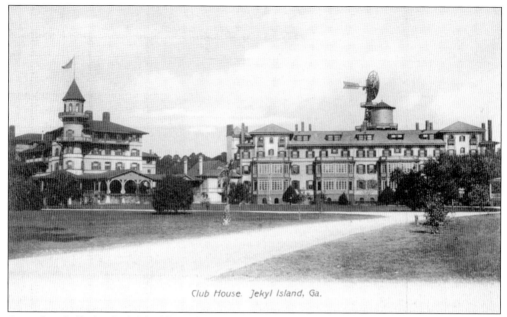

Club House. Jekyl Island, Ga.

Once the Jekyll Island Club had been fully established on paper, the task of constructing a clubhouse and designing the grounds was undertaken. No time was wasted, and ground was broken on the project in August 1886. The Jekyll Island Club officially welcomed members for its first season in January 1888.

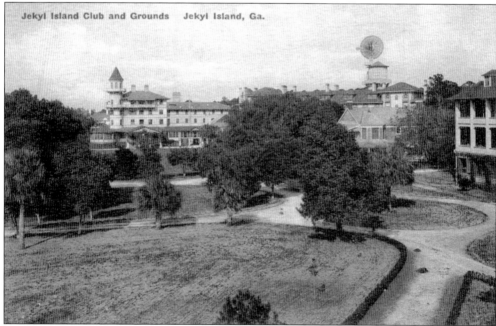

Jekyl Island Club and Grounds Jekyl Island, Ga.

The clubhouse was designed by Charles A. Alexander, an architect from Massachusetts, just two years before his sudden death in 1888. The club hired renowned landscape architect Horace William Shaler to design the grounds surrounding the clubhouse. The interweaving crushed shell roads, which are shown in this early 1900s postcard, traversed the grounds and connected the clubhouse to the surrounding cottages and auxiliary club facilities.

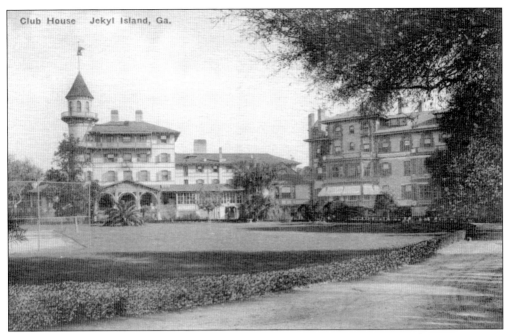

As shown on this early postcard, the front lawn of the clubhouse eventually featured a tennis court for the enjoyment of its members. Tennis quickly gained popularity among members, and indoor tennis court facilities were ultimately constructed just a few hundred feet from the clubhouse behind the Sans Souci apartments.

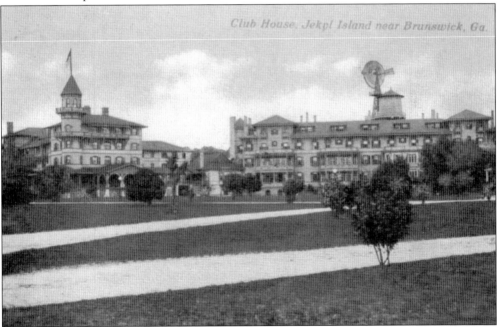

The main clubhouse building (at left) stood alone until the addition of the annex (at right) in 1901. Originally proposed by club member Henry Hyde in 1895, the annex provided much-needed additional apartments for club members and their guests. The final plans for the annex included 8 individual apartments and another 20 smaller sleeping quarters.

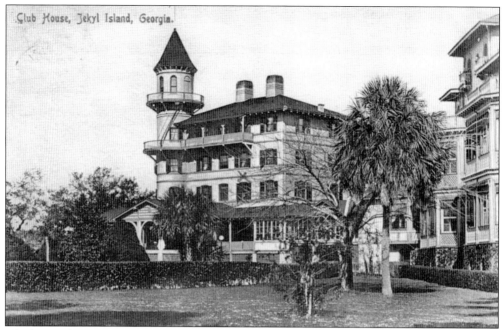

Club House, Jekyl Island, Georgia.

Charles A. Alexander designed the clubhouse in a Queen Anne style most easily recognized by the prominent turret that seems to be watching over the clubhouse and its grounds. Today, anyone who books a night in the Jekyll Island Club Hotel's Presidential Suite can enjoy the turret.

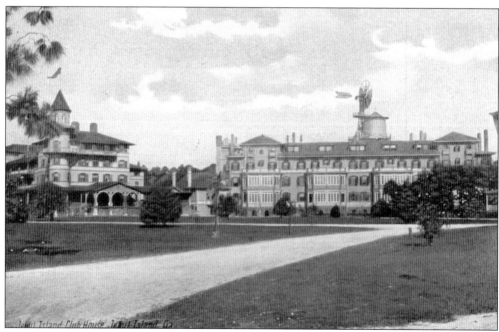

Jekyl Island Club House, Jekyl Island, Ga.

Well over 100 years after it opened in January 1888, the Jekyll Island Clubhouse, now the centerpiece of the Jekyll Island Club Resort, looks remarkably unchanged. Noticeably, there is one piece of the early clubhouse silhouette that no longer exists. The water tower and windmill that appear in many early photographs and postcards did not survive to the modern era.

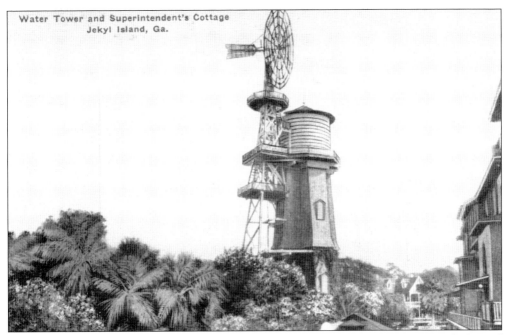

Water Tower and Superintendent's Cottage
Jekyl Island, Ga.

The water tanks and pumps used to facilitate the plumbing in the clubhouse were originally located in the attic of the clubhouse. Not long after installation, the attic system proved to be leaky and began to cause water damage within the clubhouse. This prompted the club members to search for alternatives. It was soon decided that a freestanding water tower and windmill would be built to serve as a replacement.

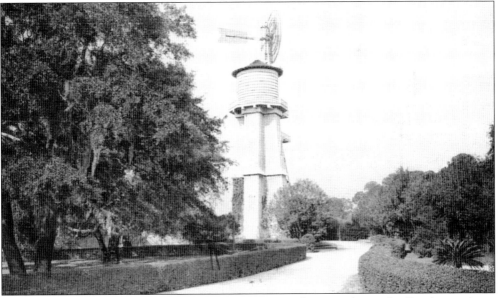

The water tower and windmill were erected in 1891. Over the years, the windmill and water tower were battered by heavy storms and hurricanes, resulting in the need for frequent repairs or rebuilds. After an exceptionally strong storm in 1928, the windmill was ultimately considered a total loss and was not resurrected. The water tower remained for many more years but was eventually dismantled following the end of the club era.

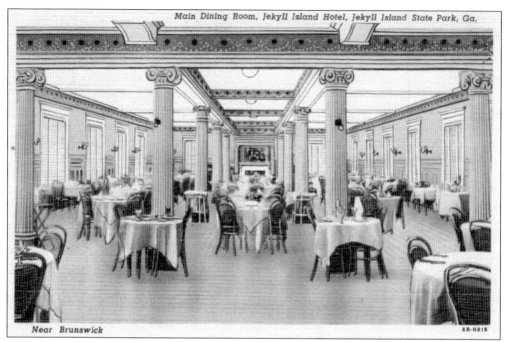

Main Dining Room, Jekyll Island Hotel, Jekyll Island State Park, Ga.

Near Brunswick

One of the most notable interior features of the clubhouse is the dining room. Modeled in a Victorian style, this opulent space welcomed countless titans of industry, heads of state, and well-to-do club members. Members and guests would gather here throughout the day for lavish meals and lively conversation. It remains nearly unchanged and still offers a premier dining experience.

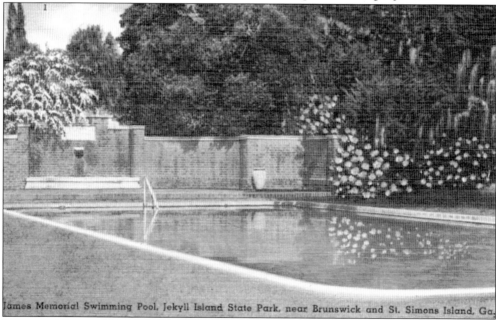

James Memorial Swimming Pool, Jekyll Island State Park, near Brunswick and St. Simons Island, Ga.

In 1927, club president Walter James, in an effort to update and modernize the club facilities, oversaw the addition of a swimming pool just west of the main clubhouse building. Because of his contributions to the club, the James Memorial Wall, complete with an artesian well, was added to the north end of the swimming pool in 1930.

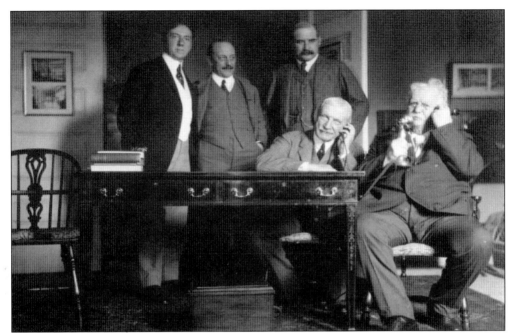

The exclusivity of the club and prominence of the club members inevitably resulted in a few historically important events taking place on the island. On January 15, 1915, club member and AT&T president Theodore Vail (seated at right) participated in the first coast-to-coast transcontinental telephone call. Also participating in the call were Pres. Woodrow Wilson, Dr. Alexander Graham Bell, and Thomas Watson. J.P. Morgan Jr. (standing at left) and William Rockefeller (seated at left) are among those pictured alongside Vail for this historic occasion. (Courtesy of Mosaic, Jekyll Island Museum.)

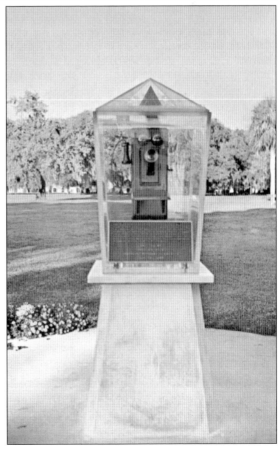

The telephone display shown here was installed on the club grounds to commemorate the historic transcontinental telephone call placed in the nearby clubhouse. Although the telephone on display was not the actual device used to place the famed call, it was of a similar style to the one used by Theodore Vail inside the clubhouse.

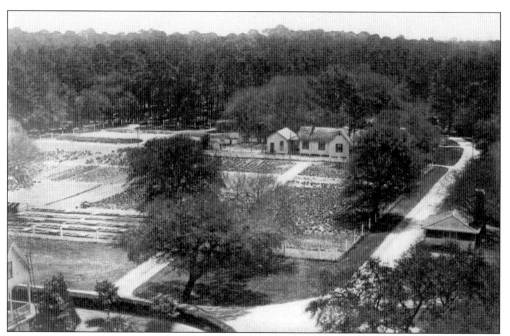

At one time, in the portion of the grounds that now houses the Morgan Center and Doc's Snack Shop, a vegetable garden was used to provide fresh produce to the club. The garden was short-lived, however, as expansions and improvements to the grounds soon took precedence.

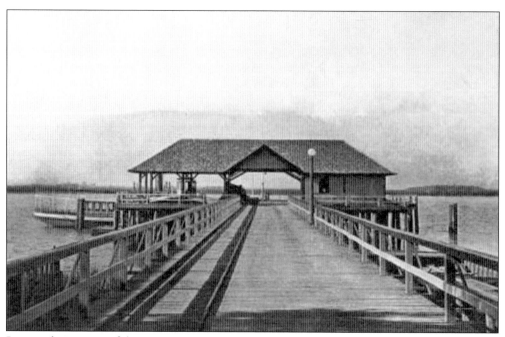

Prior to the opening of the causeway and bridge to Jekyll Island in 1954, the only way to access the island was by boat. One could either take a ferry or a private boat to the landing (pictured) located just west of the clubhouse on the Jekyll River.

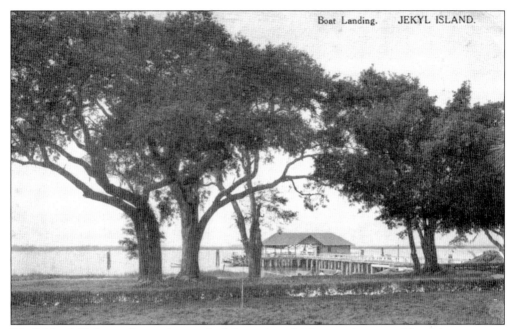

Jekyll Island Club members and guests had the option of either meeting one of the club steamers in Brunswick to be ferried over to the Jekyll boat landing or sailing their own private yachts directly to the island. Many of the members' private yachts were too large to dock at the small Jekyll wharf, so they had to be anchored off the north end of the island; the occupants were transported to the island on smaller vessels.

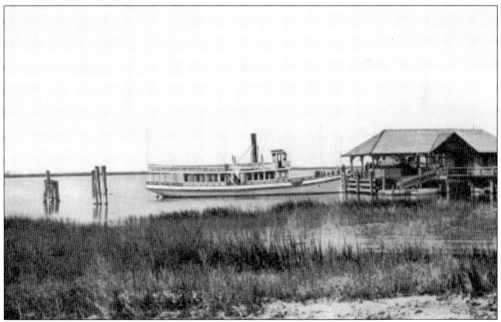

The *Jekyl Island*, pictured here alongside the Jekyll wharf, was one of the club steamers used to transport club members and guests from nearby Brunswick. This 84-foot yacht was built in 1896 and purchased by the Jekyll Island Club in 1901 to replace the aging and accident-prone *Howland*, the club's first steamship.

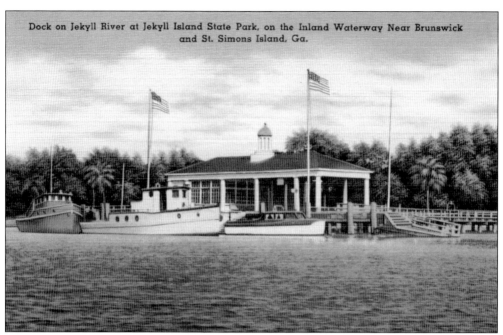

Dock on Jekyll River at Jekyll Island State Park, on the Inland Waterway Near Brunswick and St. Simons Island, Ga.

The Jekyll wharf underwent a full renovation in 1916 to give it a more stylish and modern appearance. This state park–era postcard provides an excellent view of the dock's post-renovation design, which seems to be a more fitting extension of the grand Jekyll Island clubhouse.

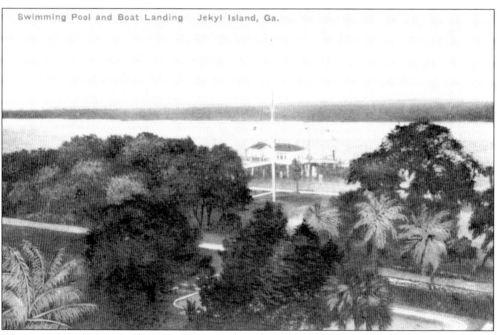

Swimming Pool and Boat Landing Jekyl Island, Ga.

The proximity of the wharf to the clubhouse is evident in this postcard that shows the view from an upper level of the clubhouse looking over the James Memorial Swimming Pool toward the boat landing. Also visible is the large nautical flagpole that was situated on the lawn between the clubhouse and the wharf.

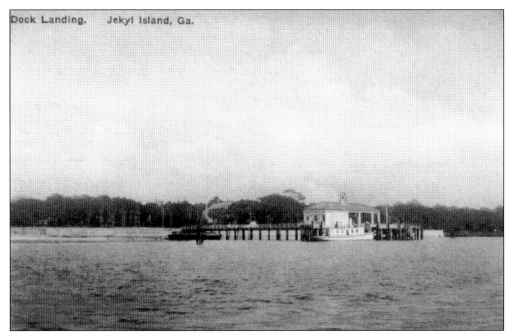

During the summer months, when club activity was at a minimum, there was no need for the larger steamer, the *Jekyl Island*, to be in constant operation. A series of smaller vessels was purchased by the club over the years to accommodate off-season needs. This postcard shows one of the smaller steamboats, the *Kitty*, secured at the dock. Named after a niece of Charles Lanier, the *Kitty* operated throughout the 1910s and was eventually replaced by the gasoline-powered *Sylvia*.

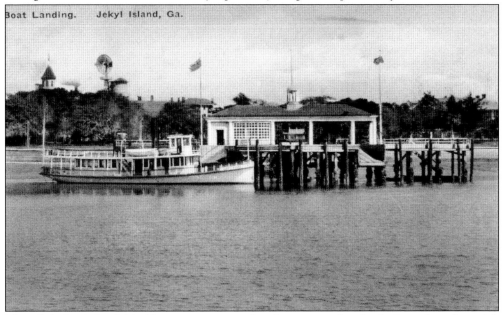

The *Jekyl Island*, the club's 64-ton steam-powered yacht, is moored to the dock, ready to ferry club members and guests to and from nearby Brunswick at a moment's notice. In the distance, the turret of the clubhouse is standing tall above the tree line with the windmill reaching just a bit higher to the right. (Courtesy of Mosaic, Jekyll Island Museum.)

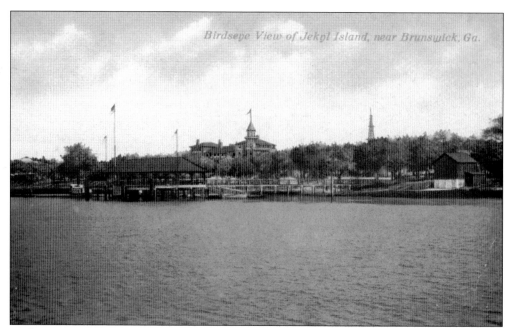

In this somewhat low-flying bird's-eye view of the Jekyll wharf and clubhouse, the boathouse is situated on the bank just south of the landing. In addition to storing supplies and tools used by the crewmen, the boathouse often housed steamers that were not currently in use by the club. (Courtesy of Mosaic, Jekyll Island Museum.)

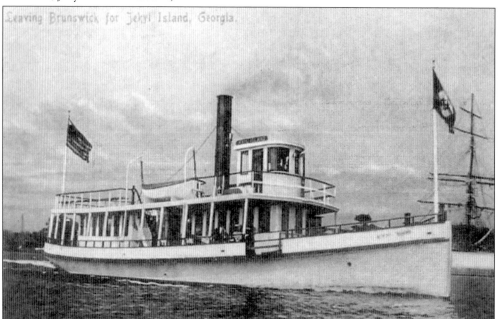

The *Jekyl Island* is pictured leaving port in Brunswick on its way to Jekyll Island. Capt. James Agnew Clark, a permanent member of the Jekyll Island Club staff from the beginning, was the full-time captain of the yacht. After Clark married the club's head housekeeper, Minnie Schuppan, the club members, holding them both in high regard, had a new cottage built for the couple. Captain Clark's Cottage, built in 1900, was conveniently located just behind the clubhouse. It was demolished in 1944.

Three

THE CLUB COTTAGES
THE JEKYLL ISLAND CLUB ERA

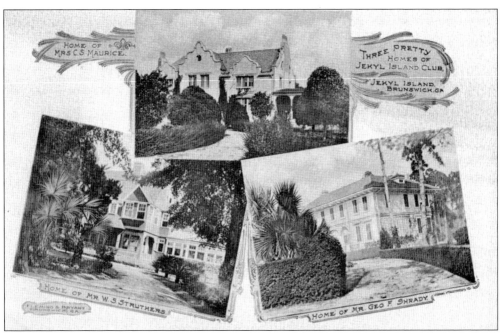

At the inception of the Jekyll Island Club in 1886, plans were made to sell 100 shares of stock with 2 shares per membership for a total of 50 members. Fifty lots were laid out within the club grounds, and members were strongly encouraged to build their own private residences. Lots were often traded and sold, and from 1888 to 1928, a total of 15 member cottages were constructed. Of those, 1 was destroyed by fire, and 4 others have since been demolished, leaving 10 structures remaining today. (Courtesy of Mosaic, Jekyll Island Museum.)

SUPERINTENDENT'S RESIDENCE, JEKYL ISLAND, GA

John Eugene du Bignon, a Brunswick entrepreneur and one of several landowners on Jekyll Island, constructed a house a few miles south of the dilapidated home of his great-grandfather, Christophe Poulain du Bignon. He purchased the remaining tracts of land in 1885, and a year later, he sold the entire island to the newly formed Jekyll Island Club. John Eugene du Bignon became the only local member of the club, retaining his membership until 1896.

After the clubhouse was completed in 1887, the Jekyll Island Club used the du Bignon house as the superintendent's cottage until 1896, when the house was relocated a short distance to make way for the construction of the Sans Souci apartment building. After the move, the house was called the Club Cottage and was available for club members to rent.

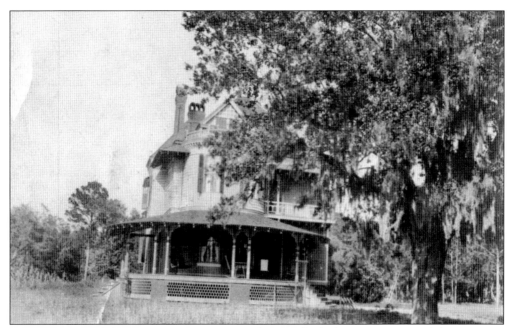

In 1888, New York businessman McEvers Bayard Brown built this Queen Anne–style cottage on an isolated lot north of the clubhouse (at the present-day location of the airport). Shortly after the cottage was constructed, Brown sailed his yacht to England and never returned to occupy his home at the Jekyll Island Club, although he remained a member until his death in 1926. The cottage was only occasionally used by club workers until it was demolished in the 1940s. (Courtesy of Mosaic, Jekyll Island Museum.)

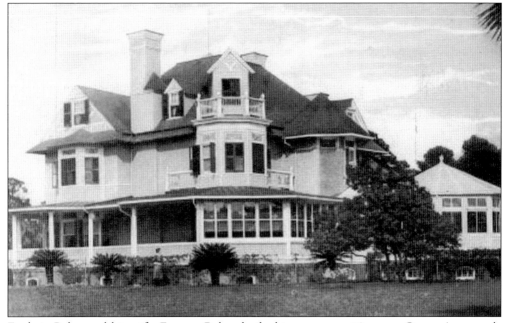

Frederic Baker and his wife, Frances Baker, built this two-story, 12-room, Queen Anne–style cottage—called Solterra—in 1890. Baker, a businessman and cofounder of New York warehousing company Baker & Williams, became a Jekyll Island Club member in 1888.

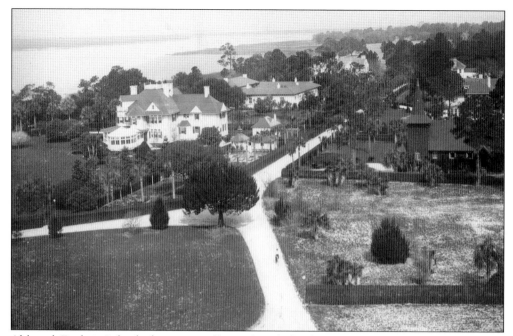

Although Frederic Baker had not originally purchased a lot share with his club membership, he was able to negotiate with the Jekyll Island Club and another club member to procure an ideal building site just north of and adjacent to the clubhouse. The Baker house, known as Solterra, is pictured here in the left center. (Courtesy of Mosaic, Jekyll Island Museum.)

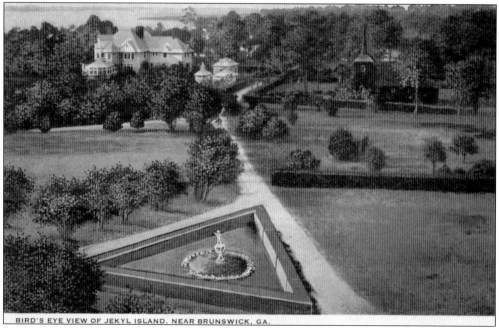

BIRD'S EYE VIEW OF JEKYL ISLAND, NEAR BRUNSWICK, GA.

Frederic Baker was quite active in the Jekyll Island Club and served as the treasurer and, later, third vice president of the club. He was instrumental in the development of the Sans Souci apartments, the club stable, the clubhouse annex, and—along with his wife, Frances—the design and construction of Faith Chapel. In March 1899, Pres. William McKinley visited Jekyll Island and stayed at Solterra.

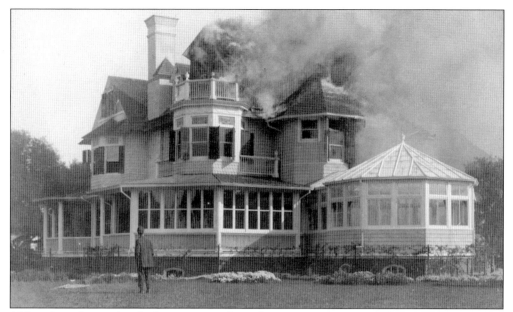

Although Frederic Baker died in June 1913, his wife, Frances Baker, returned to Jekyll Island for the 1914 season. On March 9, 1914, a fire started in the attic of Solterra (the Baker house), purportedly due to a defective flue. The wooden structure quickly burned to the ground. After the fire, Frances returned to the island just one more time—in 1916—before her death in 1919. The Solterra lot was later sold to Richard Crane Jr. (Courtesy of Mosaic, Jekyll Island Museum.)

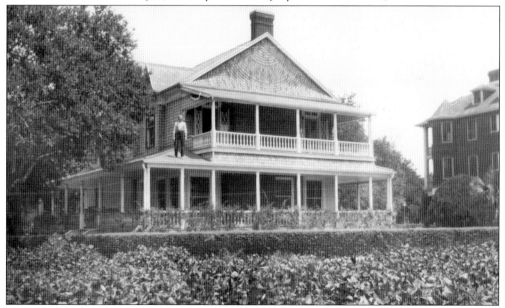

In 1890, Chicago businessman Nathaniel Kellogg Fairbank built this six-bedroom shingle-style cottage in a convenient location just south of the clubhouse, offering him an exquisite view of the wharf and river. After Fairbank's death in 1903, the home was owned by businessman Walter Ferguson until 1919, then publisher Ralph Beaver Strassberger (until 1923), then Marjorie Bourne Thayer, daughter of club president Frederick Gilbert Bourne (until 1942). The structure was demolished by 1944. (Courtesy of Mosaic, Jekyll Island Museum.)

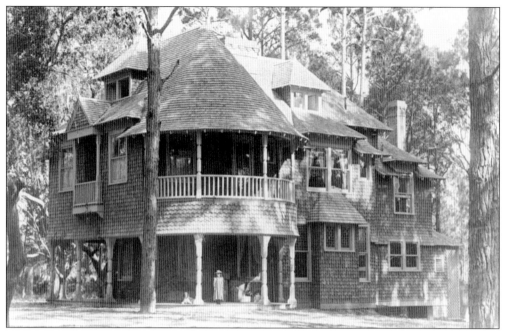

Walter Rogers Furness, the youngest of the original Jekyll Island Club members, constructed this shingle-style cottage in 1890 at the southern end of the Jekyll Island Club property. The cottage was purchased by Joseph Pulitzer in 1896, then by John J. Albright in 1914 for use as servants' quarters. Frank Goodyear acquired the cottage in 1930 and donated it to the club as an infirmary. The building was moved to its current location in 1930. (Courtesy of Mosaic, Jekyll Island Museum.)

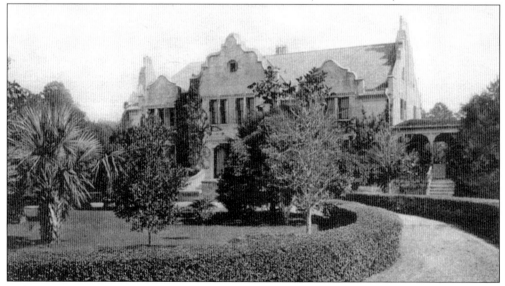

Hollybourne was the Jekyll Island home of Charles Stewart Maurice and his wife, Charlotte, and their nine children. Charles, an engineer and partner at the Union Bridge Building Company, incorporated a system of trusses in the attic that allowed for large, open first-floor rooms without the need for support beams. Built in 1890, the nine-bedroom Jacobethan-styled cottage was constructed using tabby, a coastal material consisting of lime, sand, and shells. (Courtesy of Mosaic, Jekyll Island Museum.)

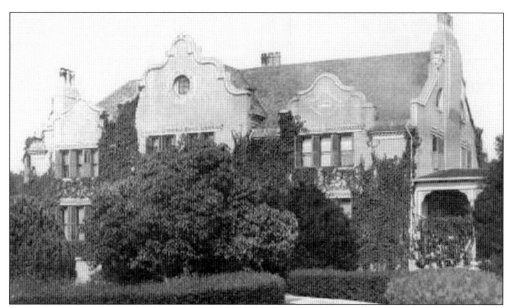

The Charles Stewart Maurice family entertained Jekyll Island Club members and guests for over 50 years. After Charles died in 1924, his daughter Margaret became a club member and, along with her siblings and their families, continued to winter at Hollybourne until the club was closed in March 1942. After World War II, the club never reopened, and the Maurice family returned only to retrieve furnishings and belongings from their beloved cottage.

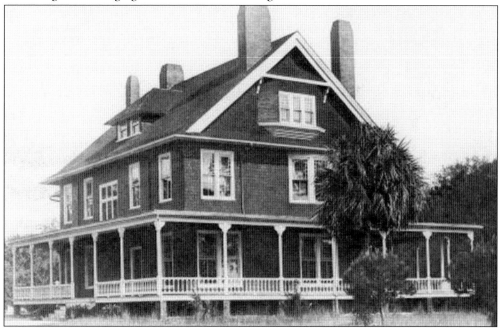

Completed in 1892, this simple, utilitarian home was built by inventor Gordon McKay on a prime lot south of the clubhouse. McKay held over 40 patents, with the most notable being his remarkable shoe-manufacturing machine that could produce up to 600 pairs per day. Quite the philanthropist, McKay made generous contributions to various Jekyll Island Club projects, including funding a bicycle path that bore his name.

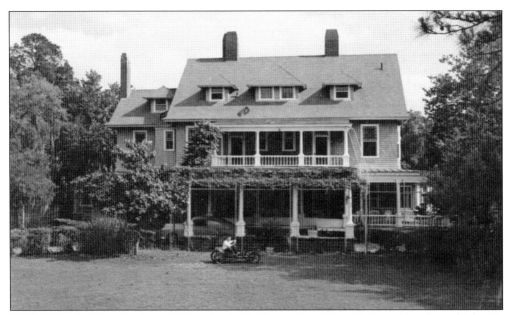

William Rockefeller, president of Standard Oil Company of New York and brother of John D. Rockefeller, purchased the Gordon McKay residence in 1905. After being renamed Indian Mound due to the discovery of an ancient shell midden on the property, the cottage underwent extensive remodeling that included a porte cochere, a second-story veranda, a parlor addition, trellises around the porch, new dormers, and the relocation of chimneys.

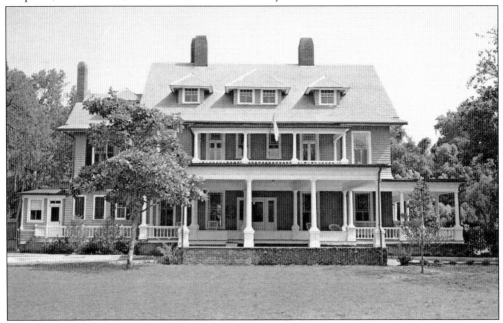

In 1924, the Indian Mound cottage was purchased by Helen Hartley Jenkins—daughter of Marcellus Hartley, the founder of Union Metallic Cartridge Company, and widow of George Walker Jenkins, the president of American Deposit and Loan Company. A club member since 1909, Helen enjoyed her home for many seasons until her death in 1934. The Jekyll Island Club took ownership of the home in 1937 and rented the cottage to various club members.

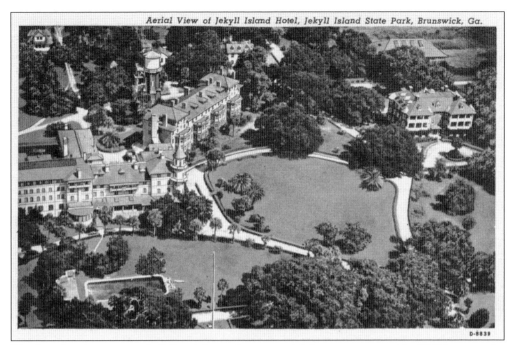

D-8839

The Sans Souci apartment building (pictured at upper right) was constructed in 1896 between the clubhouse and the Gordon McKay cottage (later called Indian Mound) on a lot previously occupied by the du Bignon house. The structure contained six multiroom apartments—two on each floor—with private verandas overlooking Jekyll Creek. An additional 12 rooms in the attic were used as servants' quarters.

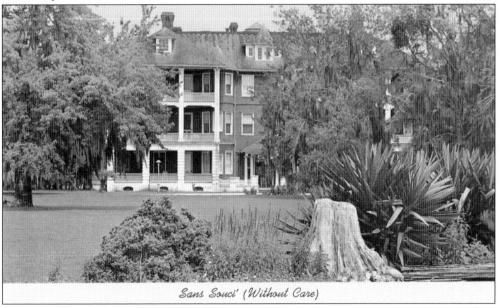

Sans Souci' (Without Care)

Although many club members rented the Sans Souci apartments over the years, the original six members, known as the Jekyll Island Associates, were J.P. Morgan (third floor north), James Scrymser (third floor south), William Rockefeller (second floor north), Henry B. Hyde (second floor south), William P. Anderson (first floor north), and Joseph Stickney (first floor south).

In 1896, William Struthers Jr., owner of William Struthers and Sons, a Philadelphia marble manufacturer, built this 19-room, 5-bath, shingle-style cottage a few lots south of the McKay house. Named the Moss cottage, it is presumably the first home at the club that was wired for electricity during its construction.

Upon the death of William Struthers, the Moss cottage was purchased, in 1912, by George Henry Macy, president of Carter, Macy, and Company, a tea importing business. In 1921, William Kingsland Macy, the son of George Henry Macy and the president of his father's business (then known as Union Pacific Tea Company), inherited the Moss cottage, and he retained ownership of it until the early 1940s.

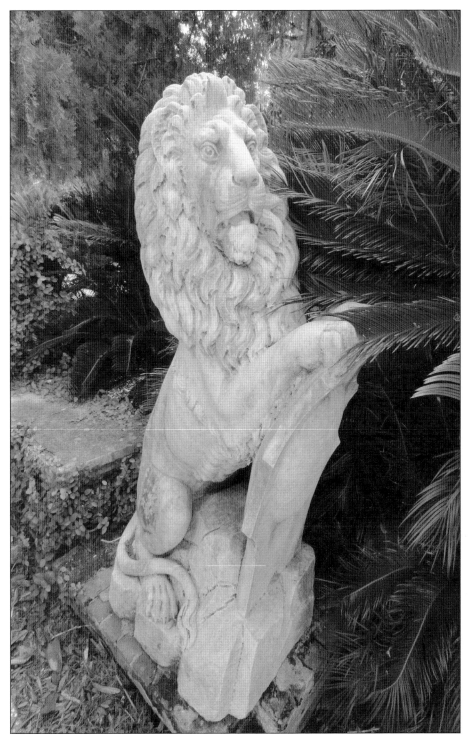

In 1897, David H. King built an Italian Renaissance–styled cottage just north of Frederic Baker's Solterra. A New York contractor, King is most known for his construction of the base of the Statue of Liberty, the Madison Square Garden building of 1890, and the Washington Arch in New York City.

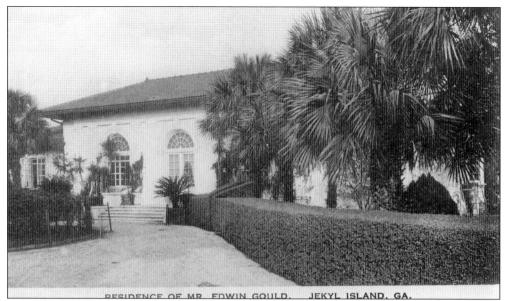

David H. King's cottage was the only single-story residence constructed by a club member and featured an atrium with an in-ground swimming pool and a pair of stately stone lions at the entrance. The house was plagued with water intrusion and flooded basements, apparently due to the use of building materials that were inappropriate for the hot and humid conditions of coastal Georgia. (Courtesy of Mosaic, Jekyll Island Museum.)

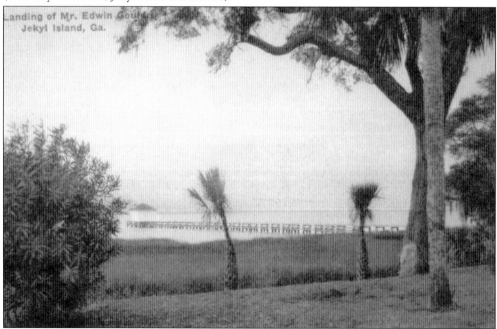

In 1900, King sold his cottage to Edwin Gould, son of railroad magnate Jay Gould, who named his new home Chichota. Edwin Gould enjoyed the quiet solitude of the island and built his own private wharf and boathouse for his yacht, the *Nada*. After the death of his son, Eddie Gould Jr., from a hunting accident in 1917, Gould returned to Chichota only occasionally. An empty pool and the stone lions are all that remain.

In 1897, Joseph Pulitzer built an eclectic brick cottage on a lot just south of the Moss cottage. A six-room addition was constructed in 1899, and another in 1904 added more bedrooms, a porte cochere, and a billiard room. Pulitzer, a renowned newspaperman, enjoyed the peaceful and natural ambience of the Jekyll Island Club, although his wife, Kate, was never enamored with the island and rarely visited.

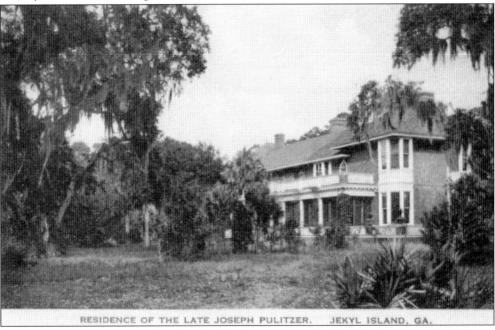

RESIDENCE OF THE LATE JOSEPH PULITZER. JEKYL ISLAND, GA.

Financier and philanthropist John Joseph Albright, who married his wife, Susan, on Jekyll Island in 1897, purchased the sprawling Pulitzer cottage in 1914 to accommodate their large family. After John Joseph Albright died in 1931, the Jekyll Island Club retained ownership of the building until the club's dissolution in 1947. After years of neglect, the structure was demolished by the Jekyll Island Authority in 1951.

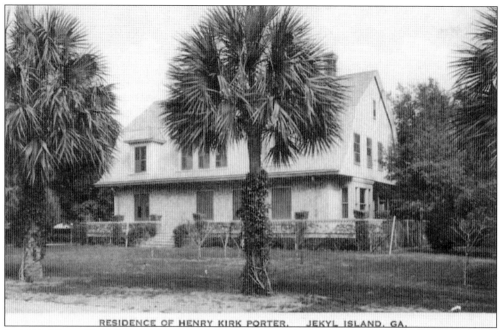

In 1900, Henry Kirke Porter constructed this 14-room, 5-bath, shingle-style cottage on the lot just south of the Gordon McKay house. Porter, a prominent locomotive manufacturer and congressman from Pennsylvania, named his home Mistletoe. He and his wife, Annie, enjoyed the entertaining and social circles of club life. After Henry died in 1921, Annie never returned to the island.

John Claflin, a mercantile merchant and president of the United Dry Goods Company, purchased Mistletoe from the Henry Kirke Porter estate in 1924. Claflin had seriously considered purchasing Jekyll Island from John Eugene du Bignon prior to the formation of the Jekyll Island Club in 1886 but ultimately supported the club proposal and became a founding member.

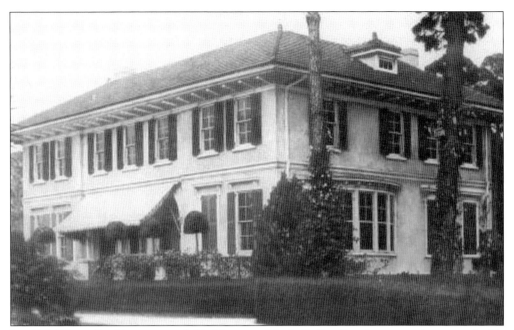

In 1904, Edwin Gould constructed this 20-room, 6-bath, Italian Renaissance–style cottage for his father-in-law, George Frederick Shrady, and his wife, Helen Shrady. George, a noted physician and surgeon, had been the editor of several medical journals and treated former US presidents Ulysses S. Grant and James Garfield in their final days. After George's sudden death in 1907, Helen continued to regularly visit the island until the accidental death of her grandson, Edwin Gould Jr., in 1917.

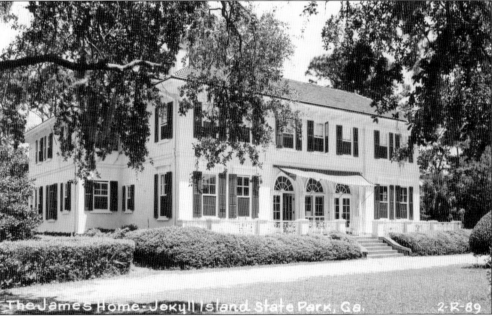

Walter B. James, a New York physician, purchased the Shrady residence in 1925 and named the cottage Cherokee. James, a popular club member and enthusiastic island supporter, was elected president of the Jekyll Island Club in 1919. After his death in 1927, his wife, Helen James, continued to visit Cherokee annually for many years, and she retained her club membership until 1942.

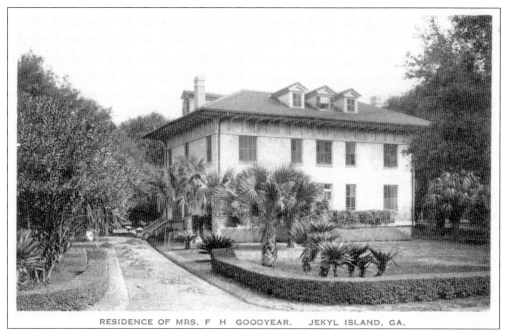

RESIDENCE OF MRS. F H GOODYEAR. JEKYL ISLAND, GA.

In 1906, this Mediterranean revival–style cottage was constructed by prominent lumber and railroad figure Frank Henry Goodyear on the lot between the Porter and Struthers homes. Goodyear spent his first and only season in the new cottage in 1907 before his death that same year. His wife, Josephine, became an active member of the club and returned annually until her death in 1915.

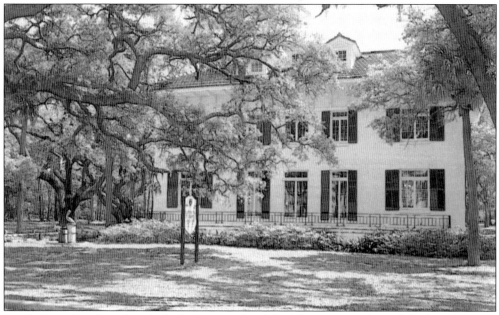

Frank Henry Goodyear Jr., who had taken over his father's businesses, inherited the family cottage in 1915 and enjoyed it until his untimely death in an automobile accident in 1930. The year after Frank died, his widow, Dorothy, married Edmund P. Rogers, a New York banker and avid sportsman who had rented the Macy home in 1930 and 1931. Dorothy and Edmund maintained the Rogers cottage until 1942.

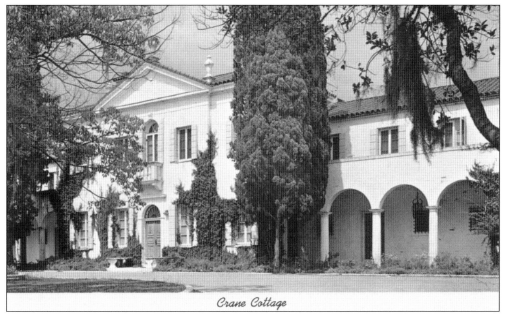

Crane Cottage

After fire destroyed Solterra, the Baker family cottage, in 1914, Frances Baker sold her lot to Richard Teller Crane, who drew up plans to build a 40-room cottage with 20 bedrooms, 17 bathrooms, a sunken garden, and a courtyard with a fountain. Crane and his wife, Florence, moved into their new home in 1919.

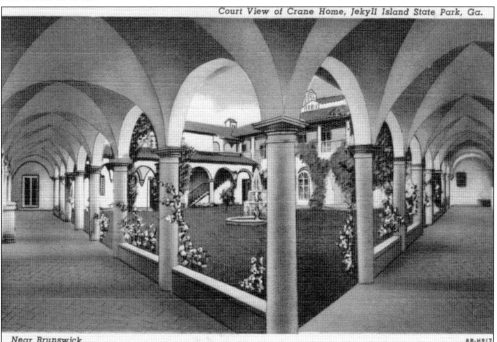

The Italian Renaissance–style home was the most expensive and opulent cottage yet built on the island, and some members feared such a magnificent structure would overshadow the clubhouse and other properties that reflected the club's conception of simplicity and informality. As a consolation, Crane removed the Italian marble floors and replaced them with wood.

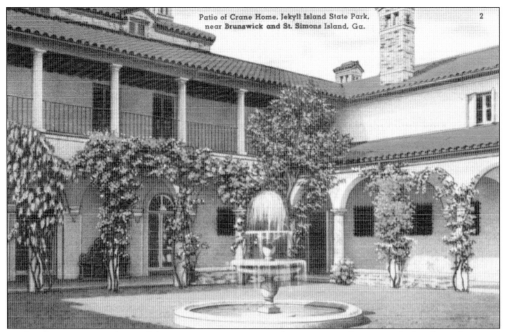

Patio of Crane Home, Jekyll Island State Park, near Brunswick and St. Simons Island, Ga.

2

Richard Crane, president of the Crane Company, a Chicago manufacturer of plumbing fixtures, pumps, steam engines, and fittings, became a member of the club in 1911 at the urging of fellow Chicagoan Cyrus Hall McCormick Jr., son of the noted manufacturer and inventor.

Richard Crane and his wife, Florence, were generous and hospitable toward club members and employees and made sizable contributions toward many club projects, including the construction of a new golf course in 1928, the James Memorial Wall at the swimming pool, and the James Dormitory for caddies. The Cranes also sponsored an annual tennis tournament, the R.T. Crane Cup.

In 1927, Walter Jennings and his wife, Jean Brown Jennings, constructed this Italian Renaissance and Spanish eclectic–style home just north of the Hollybourne cottage. Named Villa Ospo, the residence featured a tiled roof, arches over the doors and first-floor windows, stucco walls, and a covered porch. (Courtesy of Mosaic, Jekyll Island Museum.)

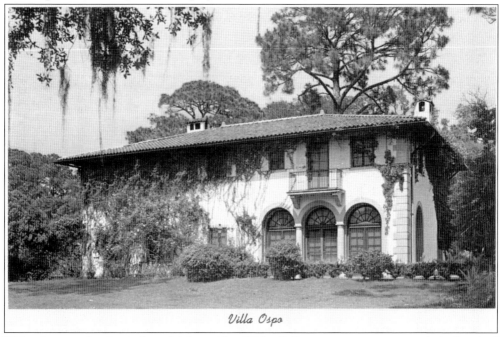

Villa Ospo

Walter Jennings, brother-in-law of club president Walter B. James, was an executive with the Standard Oil Company; his father had been an original stockholder. After James died in 1927, Jennings was elected club president after only one year of membership. Walter and Jean Brown Jennings were annual visitors to the island until Walter's death there in 1933. Jean continued to visit yearly until 1942.

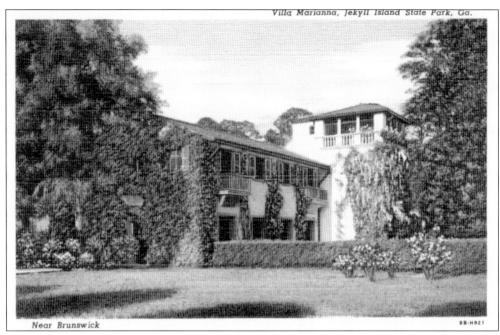

Near Brunswick

Frank Miller Gould, son of Edwin Gould and grandson of Jay Gould, built this Spanish eclectic–style cottage in 1928 just north of the James residence. Named Villa Marianna after Frank's daughter, the home had 15 rooms and 6 bathrooms and featured a red tiled roof, stucco walls, a third-floor observation deck, a courtyard with a fountain, and a reflecting pool at the entrance.

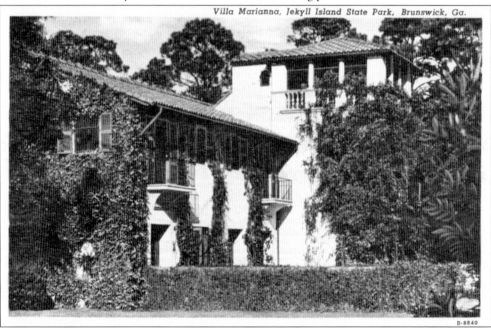

Frank Miller Gould and his brother Eddie grew up spending winters on Jekyll Island at their family home, Chichota. After Eddie's untimely death, the family visits dwindled, but after Frank married Florence Amelia Bacon in 1924, the couple returned to the island each year. After World War II, Frank led efforts to reopen the club in some fashion, but the plans fell apart after his sudden death in 1945.

Four

THE CLUB GROUNDS
THE JEKYLL ISLAND CLUB ERA

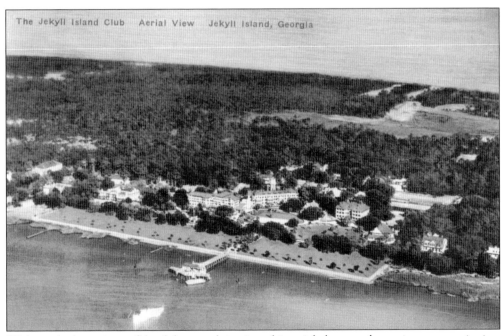

The Jekyll Island Club Aerial View Jekyll Island, Georgia

With nearly the entirety of the club grounds in view, this aerial photograph puts into perspective just how small Jekyll Island is. At roughly one and a half miles wide and seven miles long, it is hard to believe so much history and intrigue is contained between its beaches. (Courtesy of Mosaic, Jekyll Island Museum.)

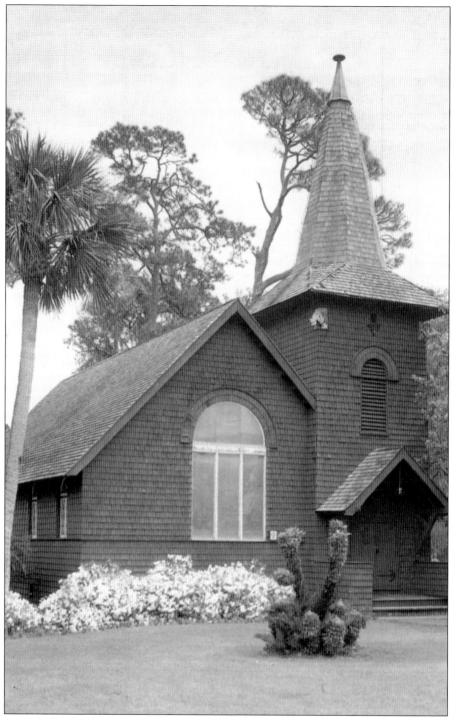

In 1897, Jekyll Island Club member Frederic Baker began to push for the construction of a nondenominational church on the island. Many of the members felt that the addition of a chapel would be the final piece in the puzzle for the club grounds and gladly donated money to the project. Despite the immediate support from club members, Faith Chapel was not completed until 1904.

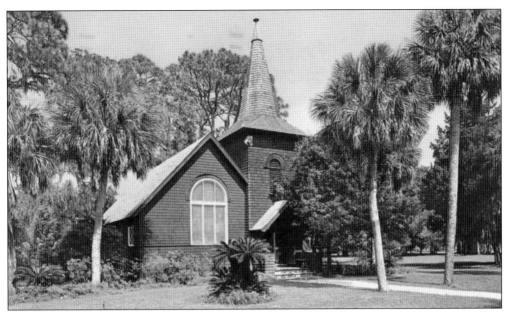

The Jekyll Island Club employed Howard Constable, a New York–based architect, to design the chapel. Although more extravagant and eye-catching designs were proposed, the original sketch by Constable was a modest wooden chapel with cypress shingles and became the winning design; this was mainly due to a lack of support for the higher price tag attached to the other plans. When it came to the club chapel, it turned out that members were happy to give—but not necessarily until it hurt.

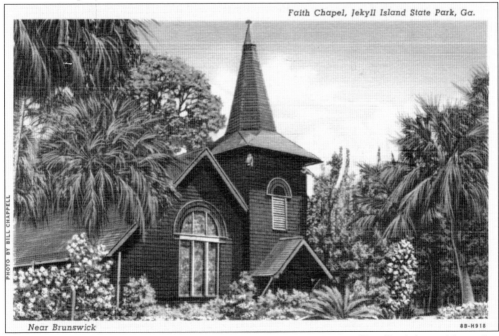

Faith Chapel, Jekyll Island State Park, Ga.

PHOTO BY BILL CHAPPELL

Near Brunswick

8B-H918

Construction began on the chapel in 1904, and Faith Chapel was officially dedicated later that year. It remained an active nondenominational church until 1942, playing host to church services, funerals, and even a few weddings. Located in the heart of Jekyll Island's historic district, Faith Chapel remains in its original location and has been beautifully maintained and preserved.

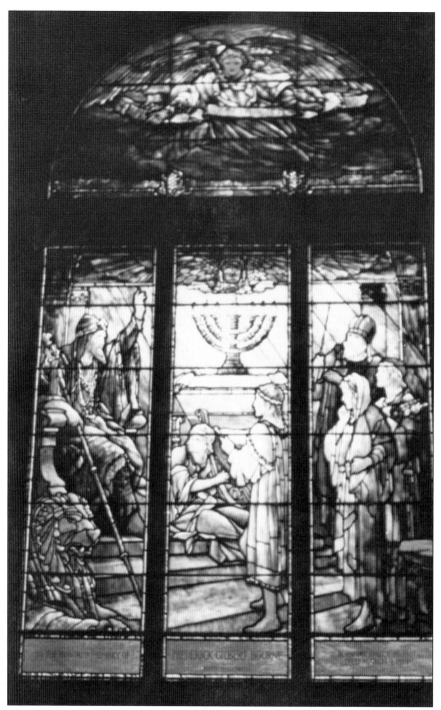

One of the most striking features of the seemingly modest Faith Chapel is the stained-glass window by Louis Comfort Tiffany. The masterfully created *David Set Singers before the Lord* was dedicated to late club member Frederick Gilbert Bourne in 1921. Bourne served for 16 years as a revolutionary president of the Singer Manufacturing Company, and it has often been speculated that the specific scene depicted in the window may have been a nod to his past.

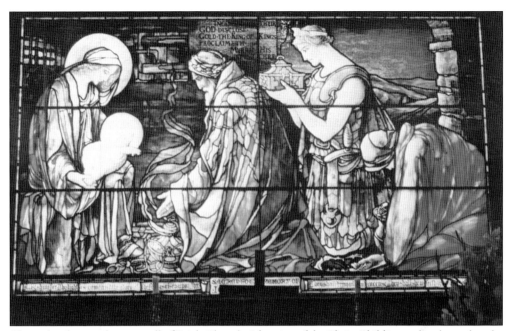

Above the altar on the east wall of Faith Chapel, *Adoration of the Christ Child* immediately catches the eye of those who enter the church. It is most spectacular in the morning hours, as the colored glass is brilliantly illuminated by the rising sun. Created in 1905 by the father/daughter duo of Maitland and Helen Armstrong, this glowing work of art depicts a scene from the story of the birth of Jesus Christ.

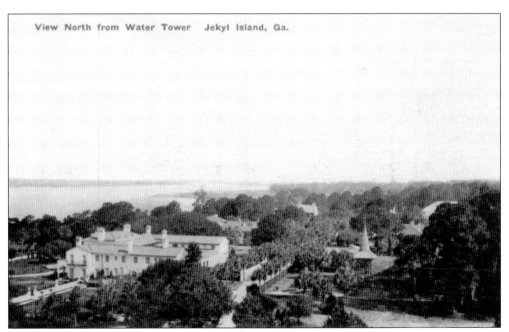

Gazing north from this high vantage point above the clubhouse, one can see Crane Cottage in the foreground with Faith Chapel directly across Old Plantation Road to the east. Beyond Crane Cottage is the Chichota cottage (now lost to time), and Hollybourne is just peeking above the trees farther north.

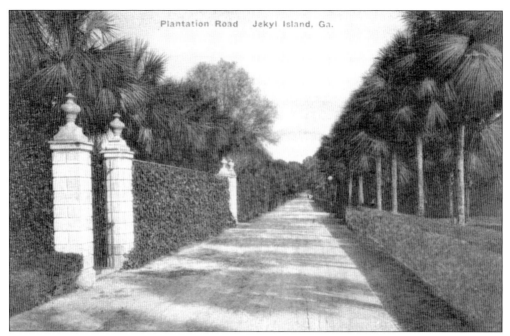

This north-facing view down Plantation Road (now known as Old Plantation Road) shows the pillars and gate belonging to Crane Cottage on the left. If one was to rotate the image to the right, it would be positioned directly in front of Faith Chapel.

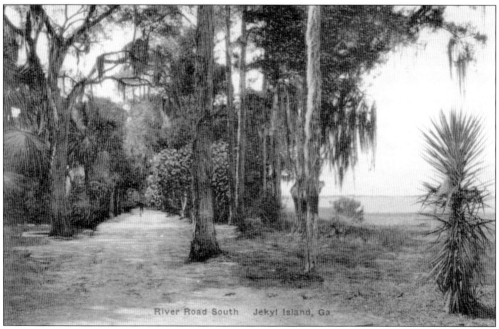

River Road ran alongside the Jekyll River on the western edge of the island in a location similar to where parts of Riverview Drive run today. Although in this early postcard, it appears to be little more than a poorly beaten path, River Road was one of the primary thoroughfares used by club members to traverse the western edge of the island in the early club era.

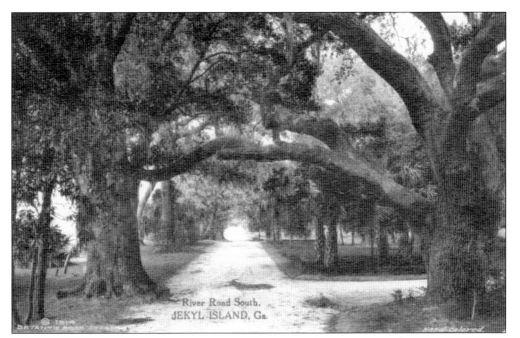

This view of River Road south is nearer to the clubhouse than the one in the prior image. Note the improved quality of the road and the more maintained look of the surrounding landscape. The large branches of the southern live oak trees on either side create quite a picturesque canopy over the roadway.

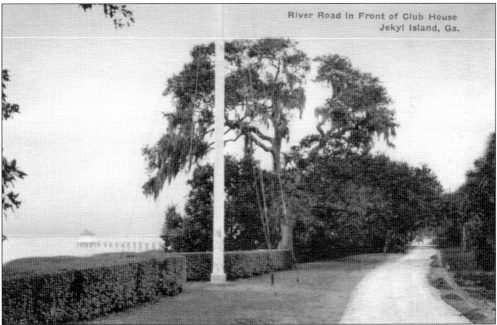

From this vantage point on River Road, once can see the lower portion of the large nautical flagpole that was situated between the clubhouse and the river as well as the private boat landing belonging to Edwin Gould (who owned Chichota). In the distance, there appears to be a small horse-drawn carriage making its way down River Road.

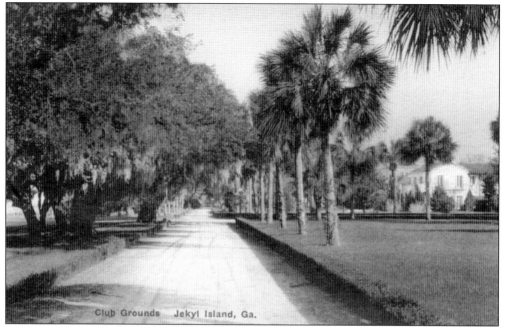

Up ahead and to the right is the western side of Crane Cottage. This photograph was taken from River Road facing north with the clubhouse directly to the right. Like many of the cottages on the grounds, Crane Cottage was built close to the Jekyll River to capitalize on the wonderful sunset views and steady breeze provided by being on the waterfront.

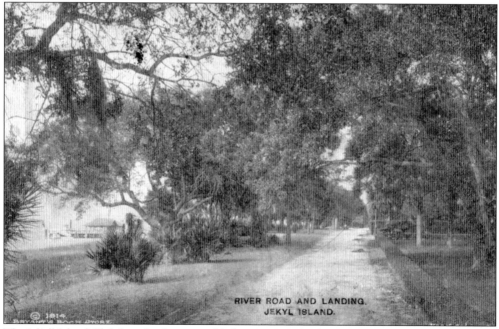

The Jekyll Island Club boat landing is visible here just south of the clubhouse on River Road. The person who took this photograph was likely standing in front of Mistletoe cottage. Many of the southern live oak trees on either side of River Road are still standing today, although they are quite a bit larger now.

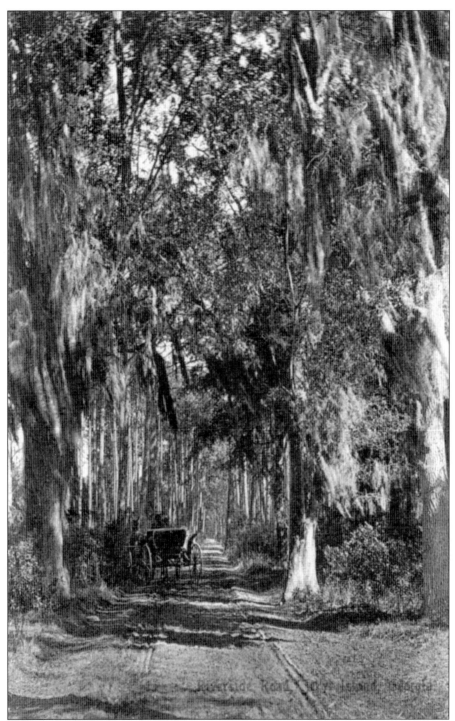

Here, the photographer, apparently struck by the natural beauty of this tree-lined road, pulled his horse-drawn carriage to the side and stepped back a few paces to capture the scene before him. The tall oaks and pines, heavily laden with Spanish moss, seem to be nearly smothering the narrow road in an unhurried but deliberate attempt to retake the cleared ground.

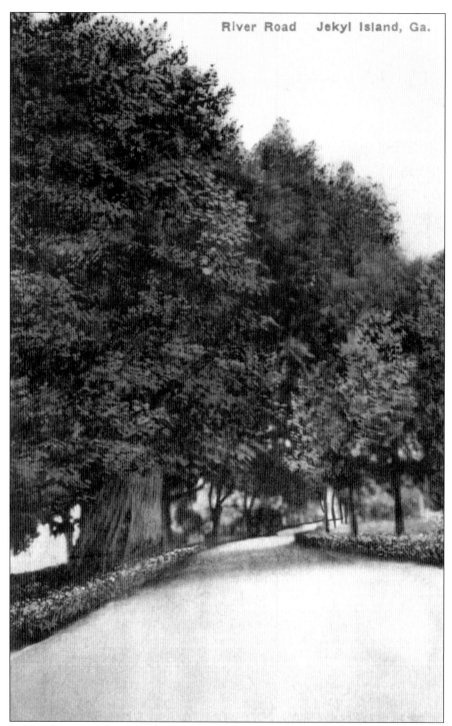

River Road Jekyl Island, Ga.

This portion of River Road seems to have an almost paved appearance. The roads around the clubhouse and cottages were covered with white crushed oyster shell and lined with perfectly trimmed shrubs and were highly maintained by the Jekyll Island Club staff. The stark contrast of the bright white roads and dark green shrubs made for an aesthetically pleasing appearance.

A one-room schoolhouse was constructed in the early 1900s for the children of the club's white employees. The building, located in an area behind Faith Chapel, was purportedly destroyed by a strong storm in the 1910s.

Around 1930, an indoor tennis court was constructed on the southeast corner of Pier Road and Old Plantation Road to allow play under any weather conditions. It was named the Morgan Indoor Tennis Court in honor of club president J.P. Morgan Jr. The building is currently the Morgan Center, a meeting and convention facility associated with the Jekyll Island Club Hotel. (Courtesy of Mosaic, Jekyll Island Museum.)

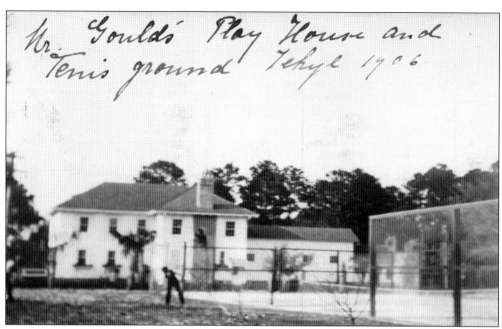

Mr. Gould's Play House and Tennis ground Jekyl 1906

In 1902, Edwin Gould constructed a recreational building just east of the Maurice cottage. The three-story casino housed a pair of bowling alleys, a gymnasium, and a shooting gallery. In 1913, an indoor tennis court was added, complete with skylights, showers, and dressing rooms. The original casino was destroyed by fire in 1950, but the indoor tennis building remains. (Courtesy of Mosaic, Jekyll Island Museum.)

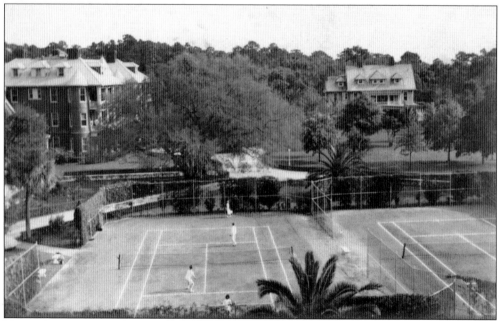

Tennis became a popular sport on the island beginning in the early 1900s. A mixed doubles tournament was held annually in the 1910s; the participants vied for the Crane Cup, a trophy donated by club member Richard T. Crane Jr. These clay-surface courts were located on the south lawn of the clubhouse. (Courtesy of Mosaic, Jekyll Island Museum.)

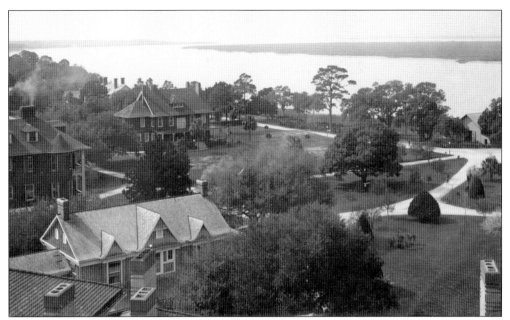

This picture, taken from the roof of the clubhouse, depicts the peace and solitude of the Jekyll Island Club. The Fairbank home is at lower left, the Sans Souci apartments are on the left, the Indian Mound cottage is in the center left, the boathouse is on the far right, and Jekyll Creek and the marshes of Glynn are in the background. A keen eye may spot a bicyclist and a pedestrian. (Courtesy of Mosaic, Jekyll Island Museum.)

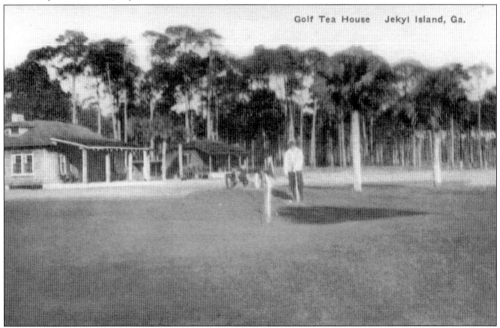

The Great Dunes course, built in 1927 and designed by Walter Travis, included nine golf holes running north of Shell Road and nine holes running south of Shell Road. A golf tea house, constructed in the present-day area of Tortuga Jack's, allowed golfers and visitors to enjoy refreshments while being entertained by the sights of the beach and sea.

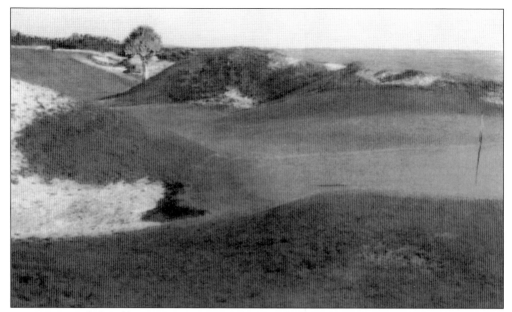

In 1898, a nine-hole golf course was constructed north of the club compound in the area of Riverview Drive, Old Plantation Road, and the airport. Designed by Willie Dunn, the course was the 38th golf course built in the United States and was overseen by the island's first golf professional, Horace Rawlins, winner of the first US Open in 1895. This postcard shows the 13th green of the 1927 Great Dunes course.

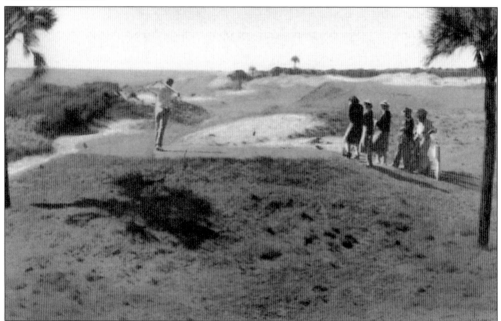

In 1910, a new course, designed by Donald J. Ross, was constructed in a marshy savanna northeast of the club grounds in the area of the current Oleander golf course. An additional two holes, financed by Edwin Gould, were built leading out to the beach dunes and could have been the precursor of the current fifth and sixth holes of the Great Dunes course. This image features what is possibly the 13th tee of the 1927 course.

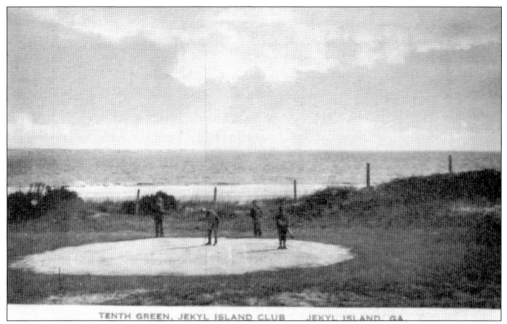

TENTH GREEN, JEKYL ISLAND CLUB JEKYL ISLAND, GA

The back nine holes of the Great Dunes course extended south from Shell Road to just past the area currently occupied by the Days Inn. These holes were severely damaged by beach erosion in the 1940s and were ultimately destroyed with the construction of Beachview Drive. This picture of the 10th green illustrates its proximity to the ocean waves.

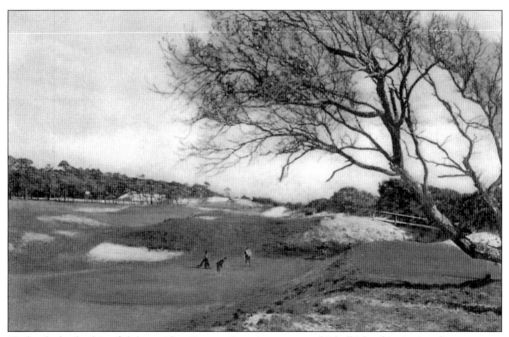

Under the leadership of club president Bernon Prentice, an annual Jekyll Island invitational tournament was played on the Great Dunes course, with the winner receiving the Morgan Cup trophy. Pictured above are the second green and the third tee of the Great Dunes course.

The layout of the front nine holes of the Great Dunes course has changed very little over the years and remains a fine example of links-style golf, with dunes, undulations, and few trees. In this picture, the two large mounds protecting the fifth green are in the upper right, and some golfers are on the fourth (or possibly seventh) fairway.

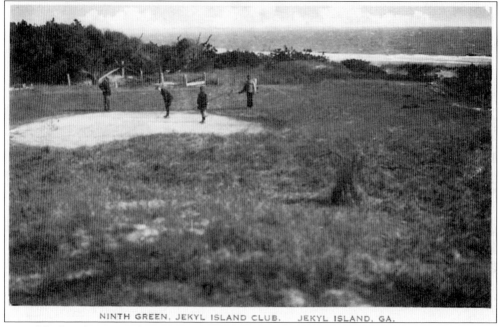

NINTH GREEN, JEKYL ISLAND CLUB. JEKYL ISLAND, GA.

One of the few changes made to the Great Dunes course since its 1927 construction involved moving the first tee and the ninth green about 50 yards to the west. The ninth green, pictured here, is the current practice putting green.

Shell Road, Jekyl Island, Georgia.

Through the years, the Jekyll Island Club developed an extensive network of roads, bridle paths, and bicycle paths throughout the island. One of the most traveled was Shell Road, a short east–west path that provided the quickest access to the beach.

Approach to Beach, Jekyl Island, Georgia.

Originating at the intersection of Old Plantation Road and Stable Road, as it does now, Shell Road was a major thoroughfare intersected by various north–south paths, including McCormick Road, Howland Road, and Morgan Road, as well as the McKay and Rockefeller bicycle paths.

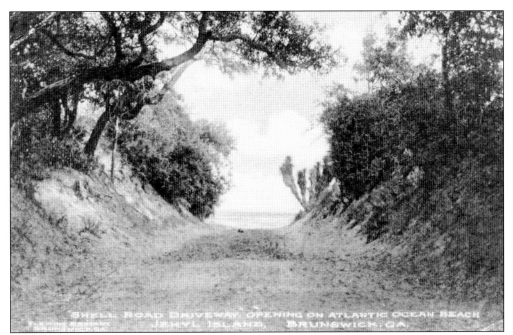

Shell Road opened onto the beach in the area of the golf house at the Great Dunes course. The golf house was located near the present-day miniature golf courses. The current bicycle path leading from the miniature golf courses toward the Mosaic travels along an earlier location of Shell Road.

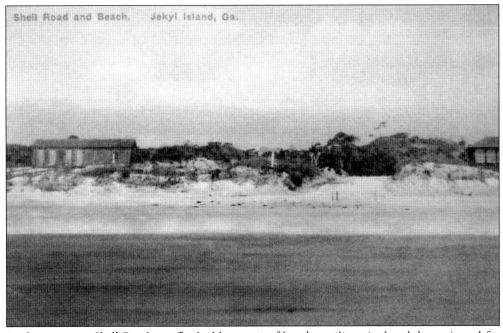

At the entrance, Shell Road was flanked by a pair of beach pavilions (or beach houses) used for social gatherings and picnics. After the construction of the Great Dunes course, the tea house was located in this area.

A popular pastime among visitors involved driving their cars and racing red bugs along the shore. Red bugs were small, motorized vehicles (similar to go-karts) that easily traveled over the compact sand of the island's beaches.

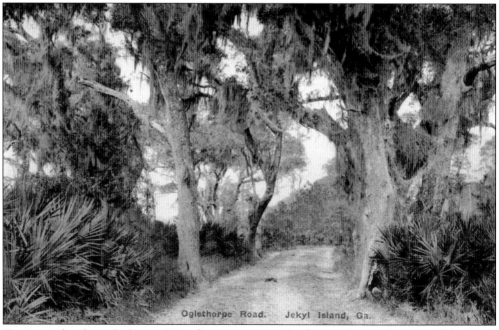

Carriage rides through the maritime forests were popular for members and guests of the Jekyll Island Club. Miles of roads and paths interlaced the island, including Oglethorpe Road (pictured).

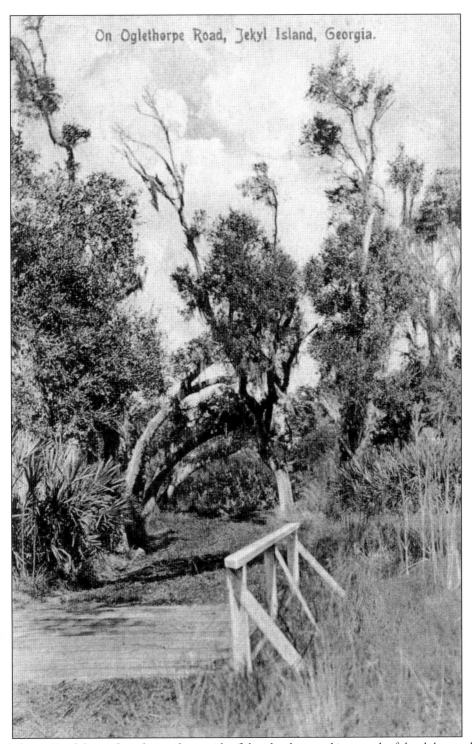

On Oglethorpe Road, Jekyl Island, Georgia.

Oglethorpe Road, located on the southwest side of the island, started just south of the club complex on River Road, meandered through the forests, and terminated at the beach near the south end of the island.

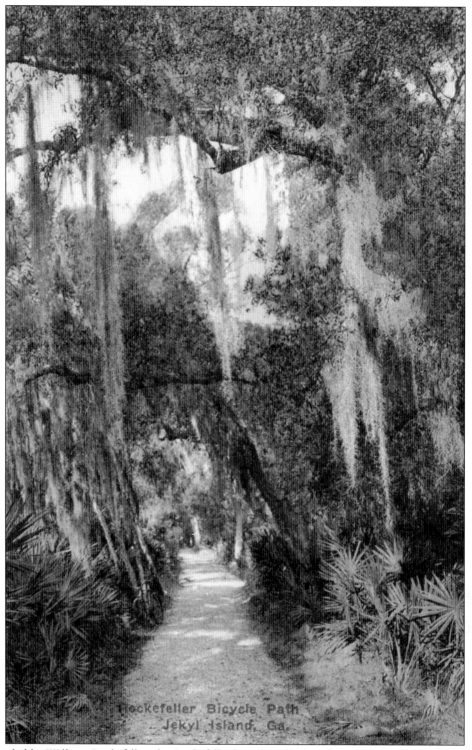

Funded by William Rockefeller, the Rockefeller bicycle path extended south from near the beach on Shell Road to its intersection with Oglethorpe Road.

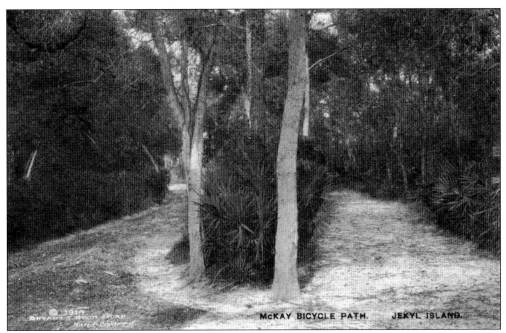

The McKay bicycle path, financed by Gordon McKay, began at Shell Road at the intersection of the Rockefeller bicycle path and traveled north past Wylly Road to its terminus at Palmetto Road. Due to his age and health, it is unlikely that McKay himself ever used his bicycle path.

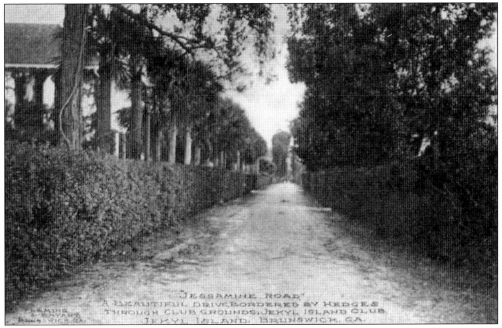

This early club-era postcard of Jessamine Road, located within the club complex, illustrates the exquisite landscaping of the club grounds filled with manicured hedges and palm-lined drives. While the stylish and upscale feel these meticulously trimmed shrubs added to the roadways cannot be denied, the maintenance required to keep them in tip-top shape for each club season was tremendous.

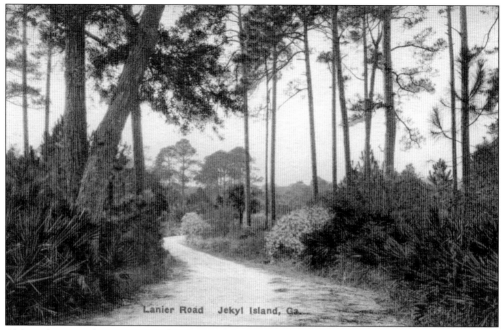

Although it is in the same general area as the current Lanier Road, the old Lanier Road, presumably named for poet Sidney Lanier, ran north from Wylly Road to Palmetto Road.

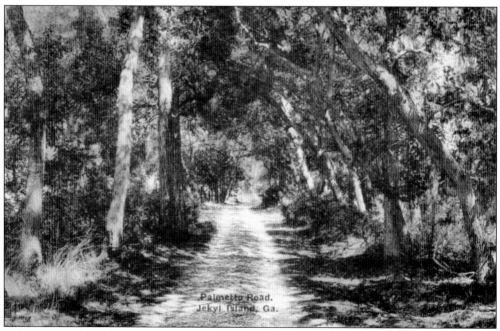

Palmetto Road, on the northern end of the island, extended east from River Road, across Old Plantation Road all the way to the beach. Palmetto Road was later renamed Baker Road in honor of club member George Fisher Baker.

Five

THE FERRY YEARS
THE JEKYLL ISLAND STATE PARK ERA

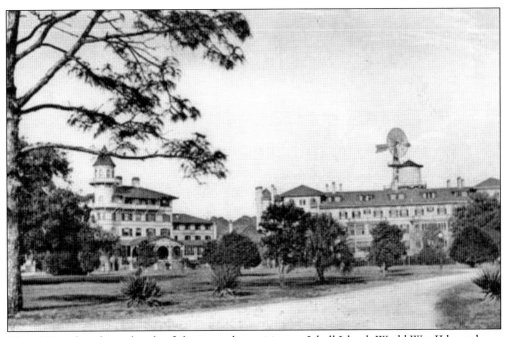

The 1940s ushered in a decade of change and transition on Jekyll Island. World War II brought an end to the most luxurious and exclusive private island club of the 20th century and gave rise to an affordable island recreational park that was accessible to anyone regardless of social status.

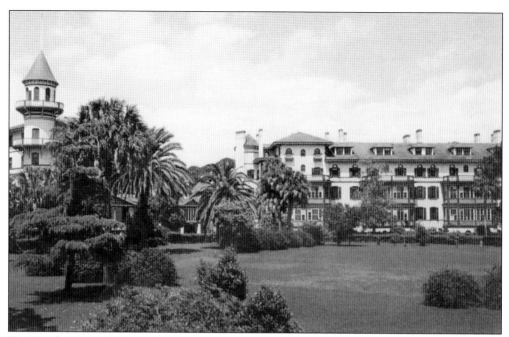

Shortly after the end of the club season in the spring of 1942, German submarine activity off the coast of Georgia prompted most of the club employees to leave the island for the duration of World War II. Servicemen from the Army and Coast Guard patrolled the island and waters, while its beaches were used as observation posts.

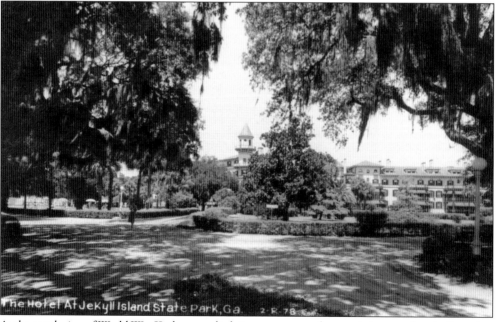

At the conclusion of World War II, there was little interest among the remaining members in financing the repairs and refurbishments that were necessary to reopen the Jekyll Island Club. The assets of the club were purchased by the State of Georgia in October 1947 for $675,000.

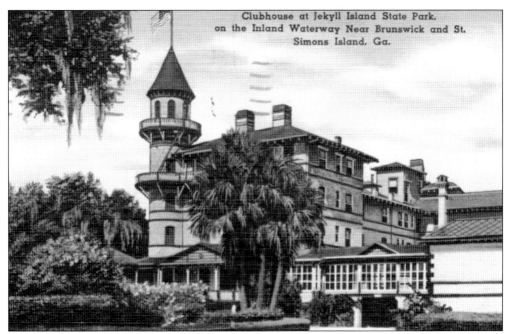

Clubhouse at Jekyll Island State Park, on the Inland Waterway Near Brunswick and St. Simons Island, Ga.

After five years of neglect, the clubhouse, cottages, and service buildings had fallen into disrepair, and the grounds and roads had become overgrown. Crews of laborers were hired by the state to make needed repairs and renovations to the buildings and clear the brush from the club grounds. In March 1948, the new Jekyll Island State Park welcomed its first visitors.

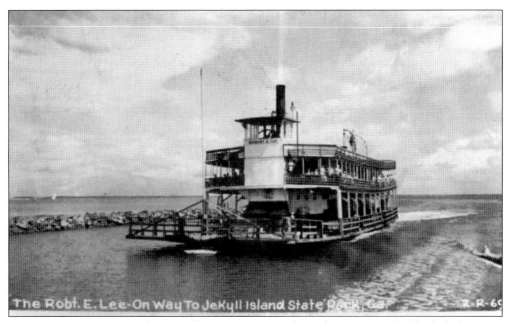

The Robt. E. Lee-On Way To Jekyll Island State Park, Ga.

Prior to the construction of the Jekyll Island causeway, the *Robert E. Lee*, a double-decked, steam-powered sternwheeler, ferried visitors from the dock at Brunswick to the Jekyll Island wharf on Jekyll Creek. The ship made several round-trip excursions to the island each day, taking about an hour each way.

The *Neptune*, a decommissioned *SC-497*-class submarine chaser, ferried visitors from the dock at St. Simons Island to the Jekyll Island wharf. Built in the early 1940s for the US Navy, the wooden-hulled, 98-ton, 110-foot, diesel-powered craft was mostly used for offshore patrols and submarine detection.

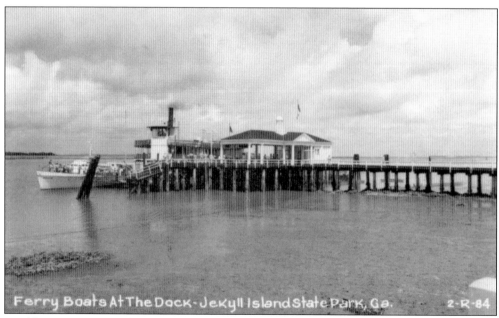

In addition to receiving island guests, the Jekyll Island wharf also served as the landing place for the supplies and laborers necessary for the operation of the Jekyll Island Hotel and other island facilities. The *Neptune* and the *Robert E. Lee* are pictured at the Jekyll Island wharf around 1948.

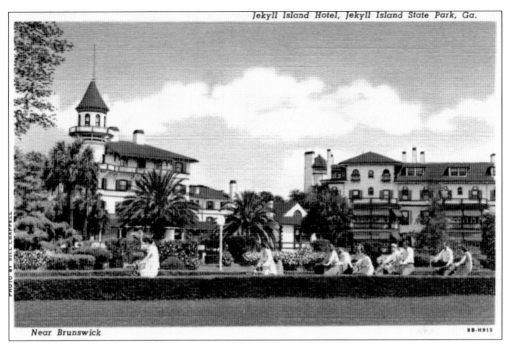

Near Brunswick

With the state park opening in 1948, the newly named Jekyll Island Hotel began accepting up to 400 nightly guests to the clubhouse, the annex, the Sans Souci apartments, and the Crane house. Many rooms were decorated with club-era items and furnishings.

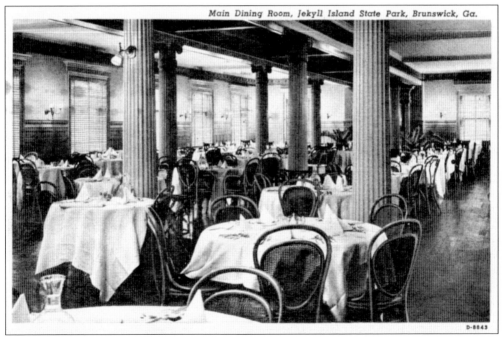

Main Dining Room, Jekyll Island State Park, Brunswick, Ga.

The dining room at the Jekyll Island Hotel was restored to its former grandeur, with beamed ceilings, ornate fluted columns, and rich wooden wainscoting. Visitors could dine on linen tablecloths while using club-era silverware and china adorned with the Jekyll Island Club emblem.

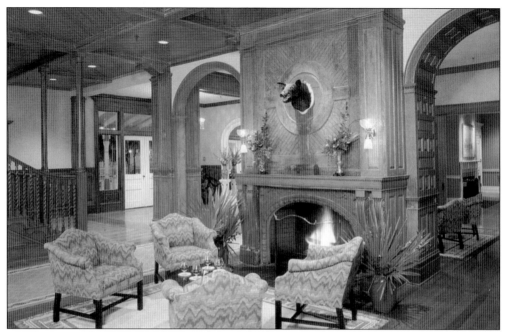

An interior view of the lobby of the Jekyll Island Hotel is accented with a wild boar's head mounted above the fireplace. Hunting was a favorite activity among the early Jekyll Island Club members, who utilized the skill of a resident taxidermist to memorialize their hunting prowess.

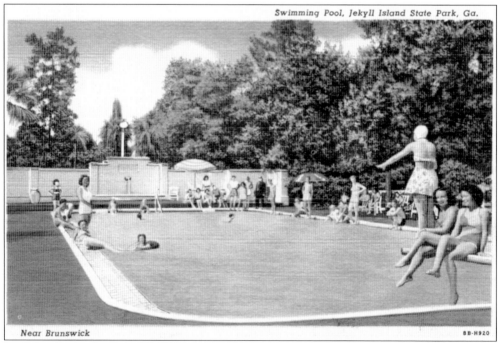

Swimming Pool, Jekyll Island State Park, Ga.

Near Brunswick

8B-H920

The Jekyll Island Hotel pool, located just outside the front entrance on the west side of the main clubhouse building, was a popular gathering spot for visitors. The water of the pool offered hotel guests a refreshing place to cool off during the island's hot summers.

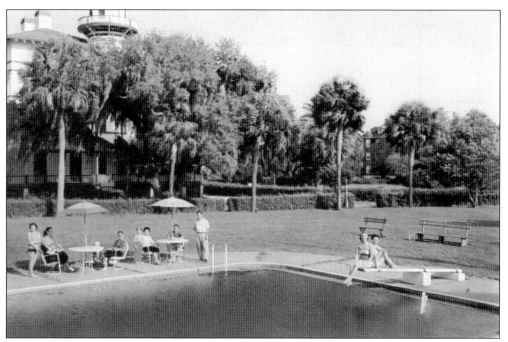

Looking southeast across the pool area and toward the front lawn of the hotel, one can see the Sans Souci apartment building through the trees. Filled by water from an artesian well, the pool was particularly cold, which may explain why none of the bathers in this photograph are actually in the water.

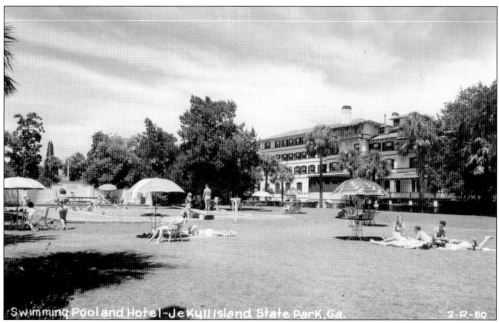

Swimming Pool and Hotel-Jekyll Island State Park, Ga. 2-R-80

The use of the swimming pool was not restricted to the guests of the hotel and was free to all island visitors. Other recreational choices at the Jekyll Island Hotel included horseback riding, tennis, croquet, horseshoes, biking, or just relaxing and sunning on the lawn.

Near Brunswick

The beautifully manicured grounds surrounding the entrance to the Jekyll Island Hotel greeted visitors who arrived from the wharf. The hotel property was adorned with various types of palms, evergreens, and ornamental trees in addition to the flowering oleanders, azaleas, and moss-draped live oaks.

At the western edge of the Jekyll Island Hotel property is a lawn and sea wall along Jekyll Creek that provides picturesque views of the creek and salt marshes—as well as sunsets. The two towers of the Sidney Lanier Bridge are visible on the horizon.

Presumed to be one of the oldest and largest live oak trees on Jekyll Island, Plantation Oak is estimated to be between 250 and 400 years old. This sprawling evergreen oak tree is located on the east side of Old Plantation Road between Crane Cottage and what remains of Chichota.

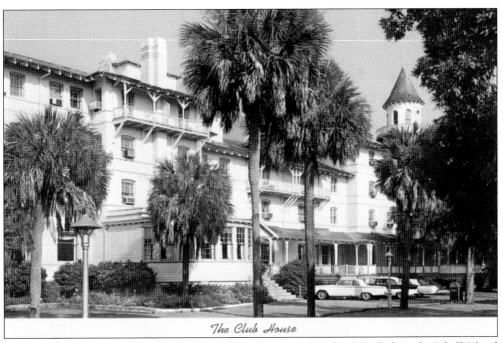

The Club House

In 1951, the Jekyll Island Authority closed all facilities on the island, including the Jekyll Island Hotel, mostly due to lack of funding. The island remained closed until the opening of the new Jekyll Creek bridge in 1954.

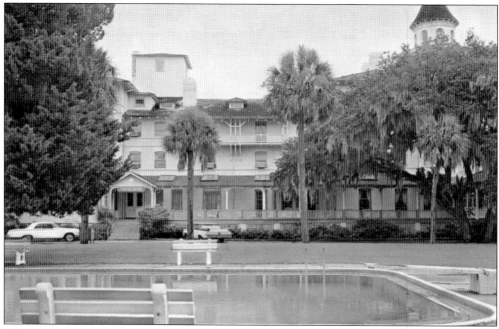

After reopening in 1954, the Jekyll Island Hotel continued to operate through the 1960s under several leaseholders, but the cost of maintaining the buildings became too burdensome, and the hotel closed in 1971. In 1985, a group of investors began to work on the major renovation and historic preservation of the dilapidated building.

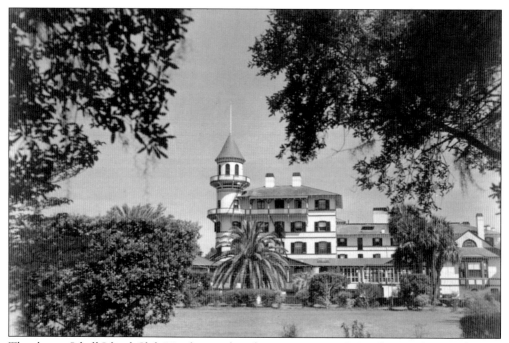

The elegant Jekyll Island Club Hotel opened its doors to guests in December 1986. Over the next few years, the hotel's footprint expanded to include the Sans Souci apartments, the Crane Cottage, the Cherokee Cottage, and the Morgan Center (formerly the Morgan Tennis Center).

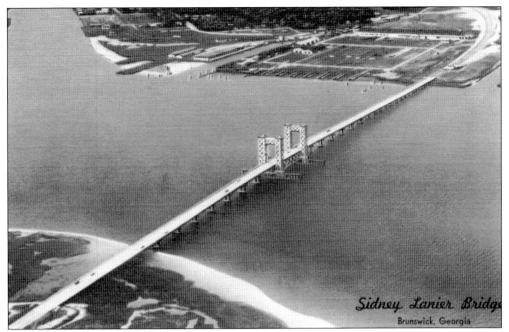

Opened in June 1956, the Sidney Lanier Bridge spans the Brunswick River at Oglethorpe Bay on US Highway 17 five miles west of the Atlantic Ocean. At four lanes and nearly a mile long, the new drawbridge greatly reduced the travel time between Brunswick and the Jekyll Island Causeway.

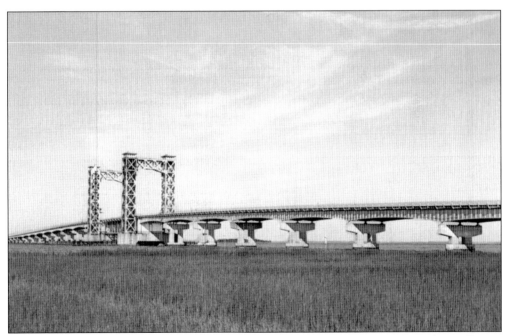

The Sidney Lanier Bridge was struck two times by shipping vessels, with each accident requiring the temporary closure of the drawbridge. This resulted in significant transportation issues for both automobiles and ships. The span was replaced in 2003 with a 480-foot cable-stayed bridge that allows nautical traffic to pass without impeding US Highway 17.

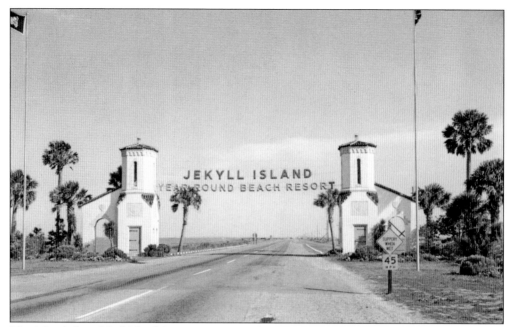

The 5.5-mile-long Jekyll Island Causeway was completed in November 1950, although the construction of the bridge over Jekyll Creek had not yet begun at that time. These Spanish-style towers, located at the entrance to the causeway at its intersection with US Highway 17, have been welcoming visitors to Jekyll Island since 1959.

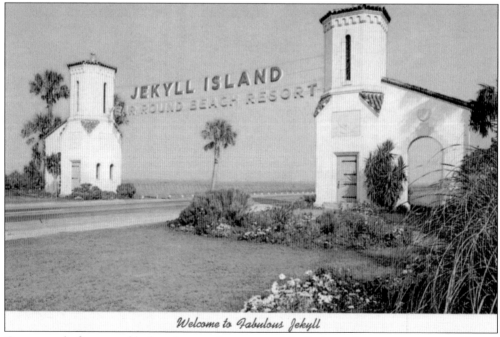

Welcome to Fabulous Jekyll

Constructed of concrete block and stone, the towers originally housed a restroom on one side and an information center on the other. The emblem of the Jekyll Island Club, with its scallop shell and cotton boll, adorns the side of each tower. Frequent visitors no doubt get a special feeling as they pass through this iconic gate to the island.

Six

THE CAUSEWAY YEARS
THE JEKYLL ISLAND STATE PARK ERA

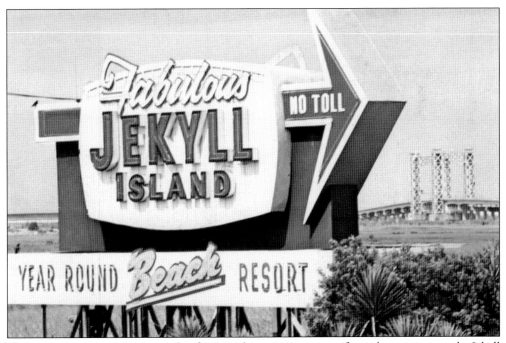

This neon sign sat on the west side of US Highway 17 just across from the entrance to the Jekyll Island Causeway and welcomed visitors to "Fabulous Jekyll Island"—an early marketing tagline used for the state park. The Sidney Lanier Bridge is visible in the background.

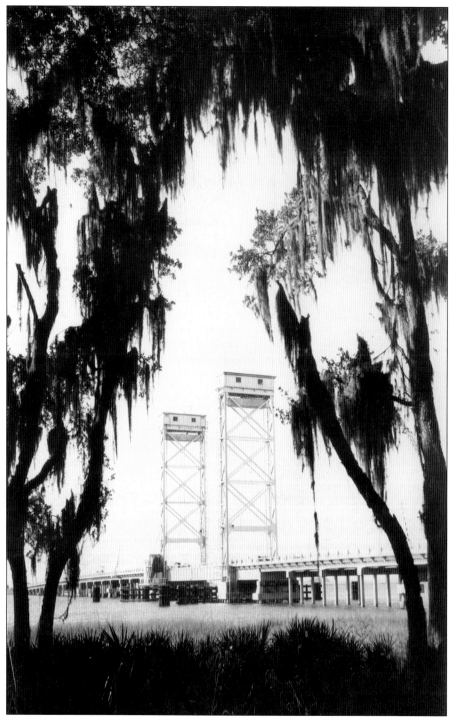

The Jekyll Island Causeway (now known as the Downing Musgrove Causeway) crosses the Jekyll Island Creek Bridge. Its opening in December 1954 coincided with the reopening of the Jekyll Island State Park facilities that had been closed since 1951. This bridge was replaced by the M.E. Thompson Bridge, a girder bridge, in 1997.

A divided entrance road, the Jekyll Island Parkway, extends about a half-mile from the foot of the Jekyll Island Creek Bridge to Beachview Drive. Around 1955, a gas and service station was constructed on the north side of the parkway and provided fuel, air, water, and minor mechanical services to island visitors.

Now known as the Ben Fortson Parkway, this gateway to Jekyll Island was constructed around stately, moss-covered live oaks and planted with ornately manicured flower gardens designed and maintained by a crew of landscapers and horticulturists using plants grown in greenhouses on the island.

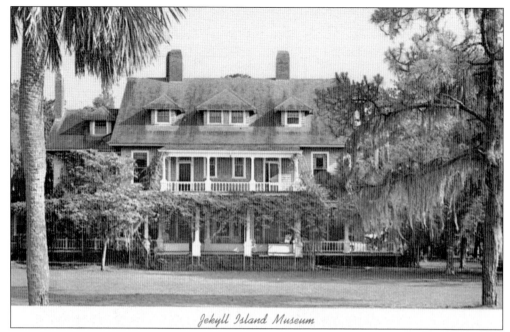

Jekyll Island Museum

In 1948, the Indian Mound cottage officially became the Jekyll Island Museum. Significant club-era items—including furniture, pottery, and taxidermy, as well as papers and documents—were collected from the clubhouse and other club buildings and stored in the cottage for safekeeping and eventually displayed in the museum.

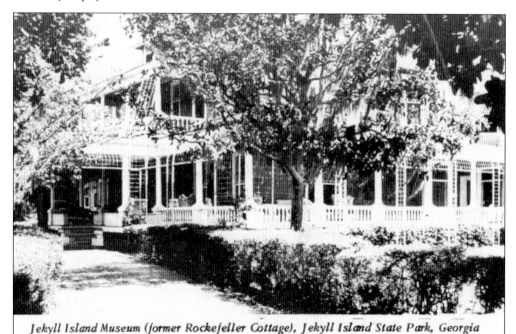

Jekyll Island Museum (former Rockefeller Cottage), Jekyll Island State Park, Georgia

In December 1954, coinciding with the reopening of Jekyll Island State Park, the Jekyll Island Museum opened on the first floor of the Indian Mound cottage under the curatorship of Tallu Fish, a noted Jekyll Island historian and author.

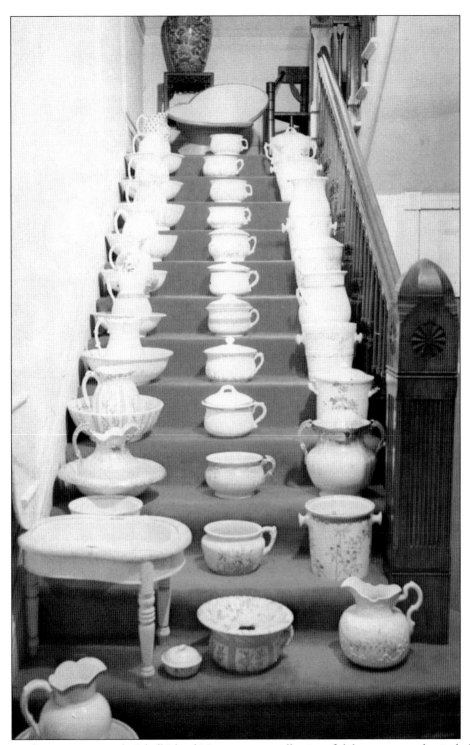

Among the many items at the Jekyll Island Museum was a collection of club-era pottery that included the ewers, basins, and chamber pots arranged here on the main stairway at the Indian Mound cottage. If only those chamber pots could speak of the many illustrious club members they had come to know.

Chinese Wishing Chair

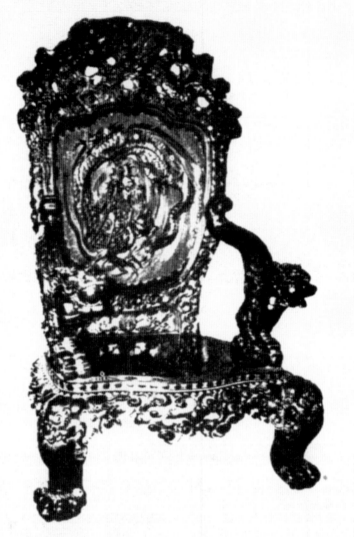

It is said to have taken a man twenty-seven years to carve this gargantuan Chinese Chair — made of Ebony An antique dealer estimated its value at $5,000. The rumor is your wish will come true if made while sitting in this chair

(WISHING WILL MAKE IT SO)

This "Chinese Wishing Chair" on display at the Jekyll Island Museum was purportedly a contrivance of museum curator Tallu Fish. In an effort to attract more visitors to the museum, a story was created about an old, ornately carved ebony chair that would grant wishes to those who sat upon it.

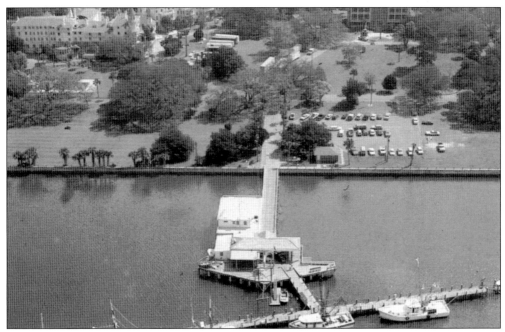

Prior to the construction of the Jekyll Island Creek Bridge, the wharf was the gateway to the island. Visitors arriving by ferry could take a shuttle bus or walk the short stroll to the Jekyll Island Hotel. For a small fee, tour buses would take visitors to the beach or to see the sights around the island.

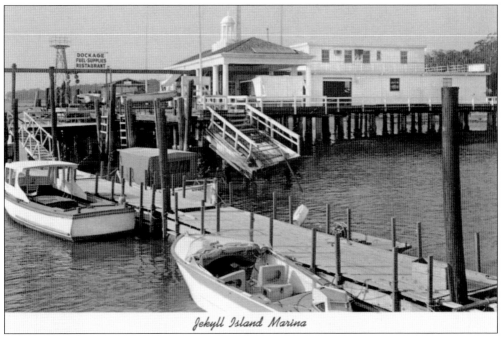

Jekyll Island Marina

The wharf was later named the Jekyll Island Marina and provided services to boaters and fishermen, including docking space, fuel, a boat launch, and bait and tackle. The name and services were later transferred to a new marina constructed south of the Jekyll Island Creek Bridge in 1989.

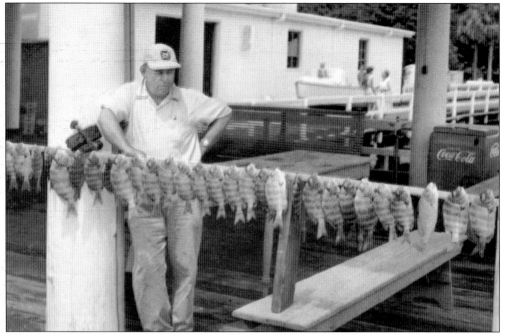

Fishing charters became a popular activity at the Jekyll Island Marina. Larry Miller, an engineer hired by the Jekyll Island Authority and the lessee of the marina in the late 1950s, is pictured with a large catch of sheepshead.

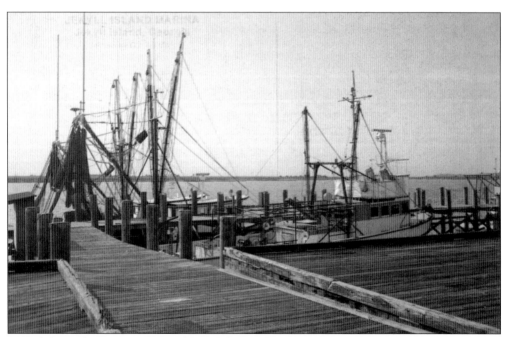

Several shrimp boats operated out of the Jekyll Island Marina until the 1980s. Freshly caught shrimp and other seafood could be purchased directly off the boat or at the small market at the marina.

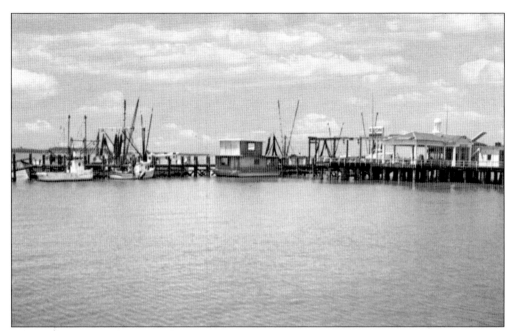

Over the years, several seafood restaurants have operated at the Jekyll Island Marina. Al fresco dining with a panoramic view of Jekyll Creek, the marshes of Glynn, and beautiful sunsets made this a popular lunch and dinner destination.

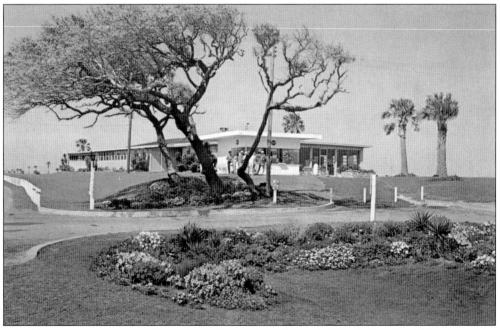

A bathhouse was constructed just above the beach at the end of Shell Road in 1948. Amenities included restrooms, showers, lockers, and concessions. In the 1950s, another concession stand, the Big Dip Dairy Barn, was built in the adjacent parking lot.

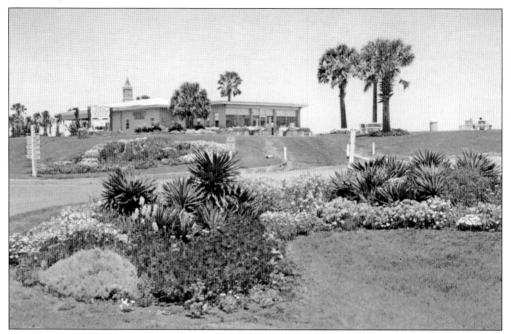

The bathhouse was converted to the Charcoal House Restaurant around 1956. This was the first of many restaurants to occupy this space. In the 1960s, it became the Sandwich Hut, followed later by Shoreline Restaurant, Shuckers Restaurant, Blackbeard's, and Fins on the Beach. Today, it is home to Tortuga Jack's.

Beach and Flowers

In 1957, a concrete boardwalk was constructed from just south of the Wanderer Motel to the Corsair Motel site. Benches, water fountains, and palm trees were placed along the walkway, which is nearly two miles long. Today, a section of the original boardwalk is still being used just north of Tortuga Jack's restaurant.

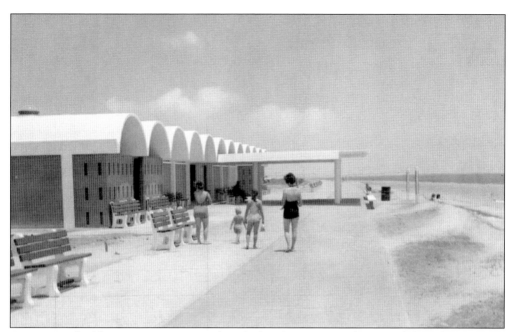

In 1957, two bathhouses were constructed on the beach approximately one and three-fourths miles apart. Each bathhouse provided showers, lockers, restrooms, and concessions for the convenience of beachgoers.

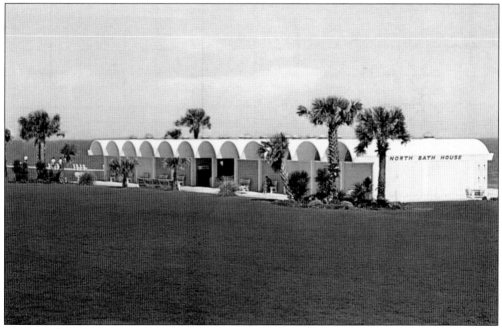

The North Bath House was located just south of the intersection of Captain Wiley Road and Beachview Drive, while the South Bath House was located just north of the Corsair Motel. The bathhouses had similar architecture and a corrugated roof style that would also be used in the original shopping center.

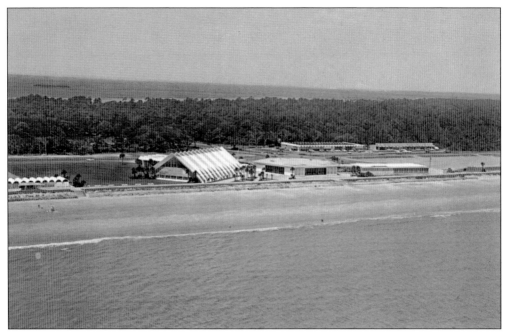

The South Bath House is visible here (at far left) along with the Aquarama, the convention facilities, and two shopping center complexes. Sadly, none of these iconic buildings exist today, as this is the current site of the Beach Village shopping and dining area, the Westin Hotel, the Jekyll Ocean Club Hotel, and the Jekyll Island Convention Center.

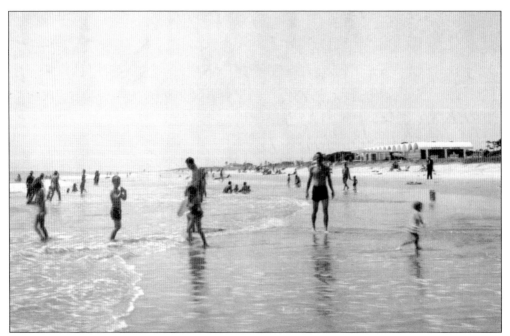

Jekyll Island visitors are shown enjoying the beach between the North Bath House (pictured) and the Wanderer Motel. The beach areas around the bathhouses were especially popular due to the convenient access for beachgoers. The bathhouses were demolished in 1984 due to corrosion of the concrete.

Between 1956 and 1960, several public picnic areas were constructed around the island with picnic tables, charcoal grills, and (eventually) restrooms. A concrete plant was built a few years later to produce the benches, tables, posts and other items used all around the island.

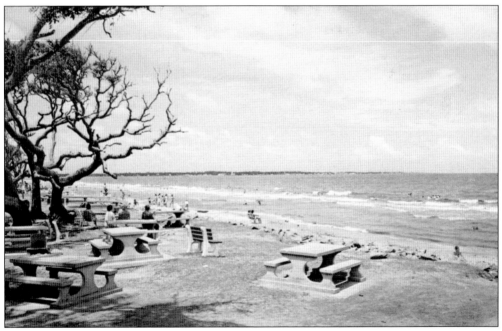

Little remains of the north picnic area once located just south of Driftwood Beach. This scenic spot beneath the live oak trees offered unencumbered views of the Atlantic Ocean and neighboring St. Simons Island. Although the area was closed in 1987 due to beach erosion, one can still find pieces of the concrete benches and tables embedded in the sand.

The south picnic area was originally built just south of the Corsair Motel but was moved, in 1960, to allow for the construction of the Buccaneer Motel. Now called the South Dunes Picnic Area, this quiet, wooded park boasts freshwater ponds and large sand dunes that are traversed by a boardwalk to the beach.

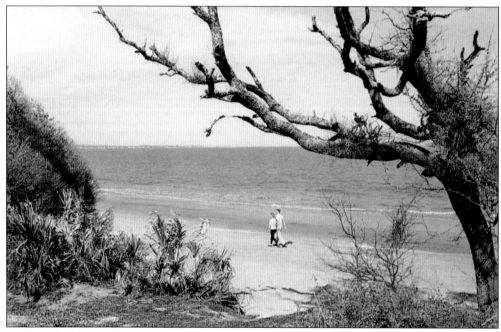

Another picnic area was opened in 1960 at St. Andrews Beach on the southern tip of Jekyll Island. This area, located along the Jekyll Sound, is popular with fishermen, seiners, and wildlife watchers, as well as swimmers and sunbathers.

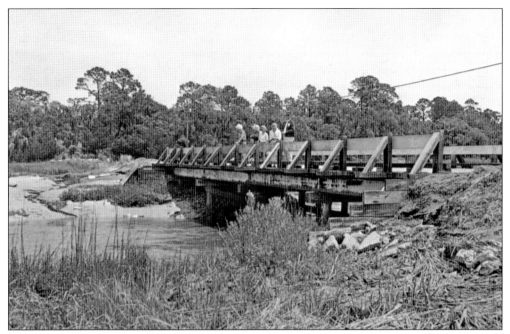

The Clam Creek Picnic Area was constructed at the northernmost point of Jekyll Island beside the marshes of Clam Creek. A bridge built over the tidal creek is a popular fishing spot and allows visitors access to the northern section of Driftwood Beach.

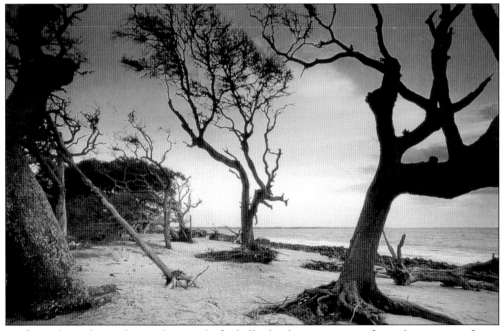

Driftwood Beach, on the northern end of Jekyll Island, gets its name from the remains of sun-bleached oak and pine trees that litter the shore. These trees are the ghosts of a maritime forest that has slowly succumbed to erosion and tides. This beach is a haven for weddings and photographers.

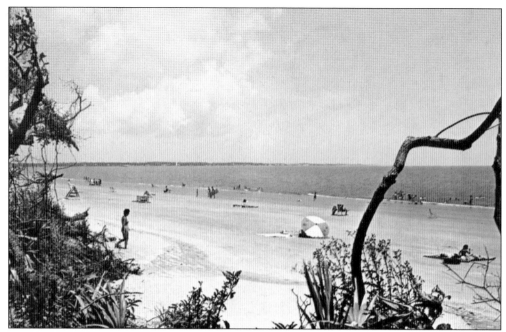

Beginning in 1957, during the summer seasons, lifeguards were hired to monitor the most popular beach swimming areas. Red-and-white portable lifeguard stands were manned during peak beach hours—weather permitting—until the lifeguarding was discontinued in the mid-1980s. One of the stands is visible in this picture.

The focal point of the Jekyll Island experience has always been its 10 miles of unspoiled beaches. In recent years, numerous beach parks have been constructed along Beachview Drive to provide ample parking, pavilions, and restrooms for larger groups and beach events.

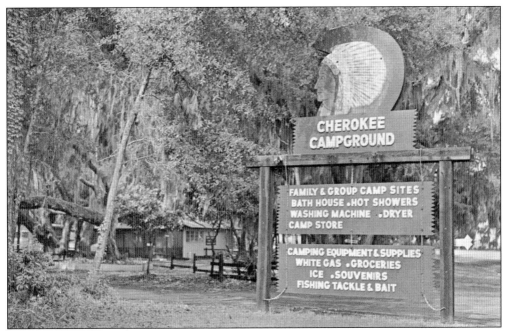

In 1958, the 18-acre Cherokee Campground was established in a beautifully wooded area at the intersection of Clam Creek Road and Beachview Drive. The $2 per night campsite fee allowed access to overnight accommodations on the island to an even greater number of visitors.

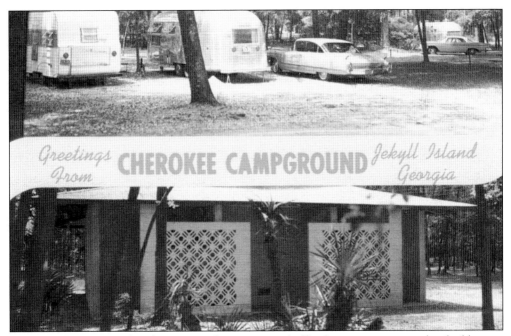

Catering to both tent and trailer campers, the campground offered guests amenities such as bathhouses, washing machines, fire pits, and a camp store for groceries and camping supplies. Electrical outlets and water spigots were installed at many of the sites.

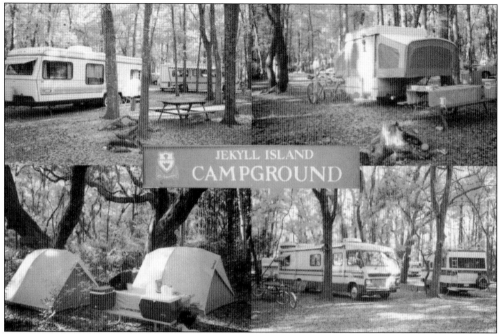

In the mid-1980s, the Jekyll Island Authority took over the operation of the campground and renamed it the Jekyll Island Campground. Changes have been made over the years to provide necessary space and hookups for larger recreational vehicles while retaining a more primitive area for tent campers.

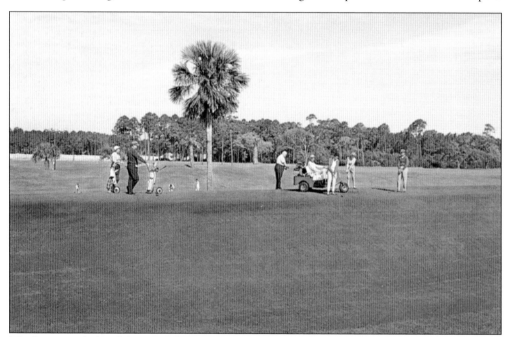

The front nine holes of the original 1927 Great Dunes golf course opened for public play as the Jekyll Island Golf Course in 1955. The back nine holes of the old course, which ran south along the beach to just past the Corsair Motel site, had become unplayable since the mid-1940s due to damage from weather and tides and were demolished in order to build Beachview Drive.

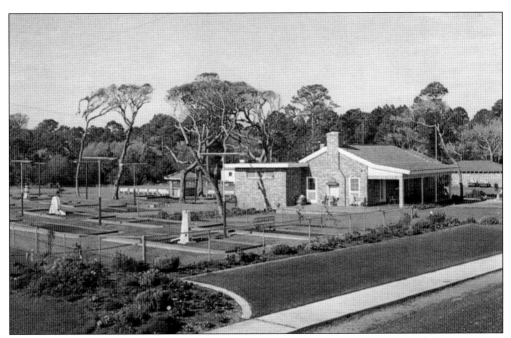

In 1958, a new golf clubhouse was built at the Jekyll Island Golf Course just across Beachview Drive from the Charcoal House Restaurant. It was constructed using salvaged bricks from the Pulitzer-Albright cottage, which had been demolished in 1951. The building is currently the home of Red Bug Motors Pizza.

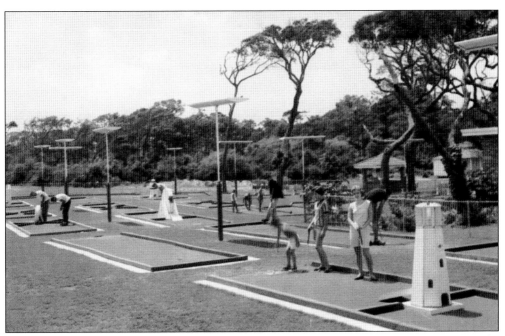

A new 18-hole miniature golf course opened in 1958 adjacent to the new golf clubhouse at the Jekyll Island Golf Course. The addition of lights around the course allowed for cooler—but also buggier—evening play.

The miniature golf course was later expanded with the addition of another 18-hole course. Bicycle rentals were added in the 1980s as more bike paths began to be constructed. There are now approximately 25 miles of paved bicycle paths that meander through the island.

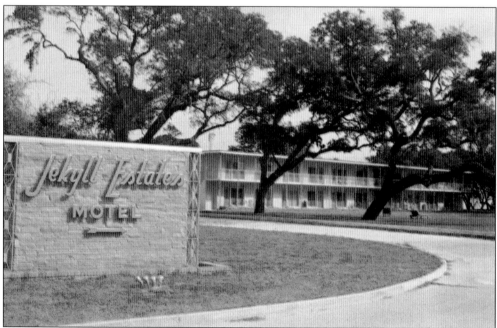

After the state park opened in 1948, the only accommodations on Jekyll Island were at the Jekyll Island Hotel on the riverside. That changed in 1958 with the opening of the first oceanside motel, the Jekyll Estates Motel. At this beautiful site just north of Captain Wiley Road on Beachview Drive, visitors can enjoy a spectacular view of the ocean while basking in the shade from a canopy of live oaks.

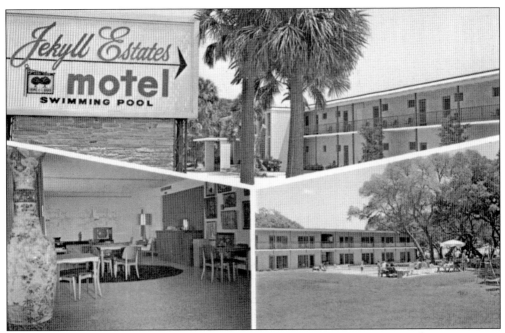

A new wing was added to the Jekyll Estates Motel in 1959, increasing the total number of rooms to 36. Despite being the smallest motel on the island, it became a favorite for many vacationers. The motel was remodeled in 1997, and the name was changed to Beachview Club Resort.

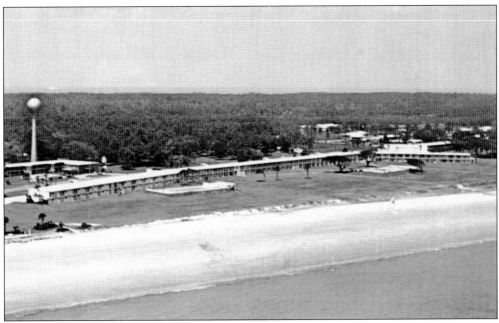

Located just south of the Jekyll Estates Motel at the north end of the boardwalk, the Wanderer Motel, named for the infamous slave ship, opened in 1958 with 96 rooms, many of which were efficiency suites that included a kitchenette and a living and dining area.

With the addition of 84 more rooms in 1959, the Wanderer Motel offered guests a panoramic view of the Atlantic Ocean, an on-site restaurant, and a choice of two beachfront swimming pools. The southernmost swimming pool was removed around 1970.

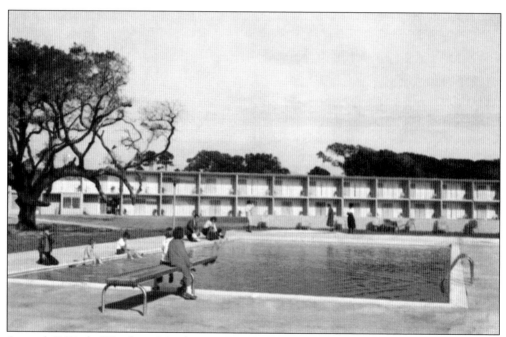

Around 1987, the Wanderer Motel was renamed Comfort Inn Island Suites, and in 2015, the building was completely refurbished and reopened as the Holiday Inn Resort Jekyll Island. The old restaurant structure was razed, and a new privately owned restaurant, the Beach House Restaurant, was opened by 2016.

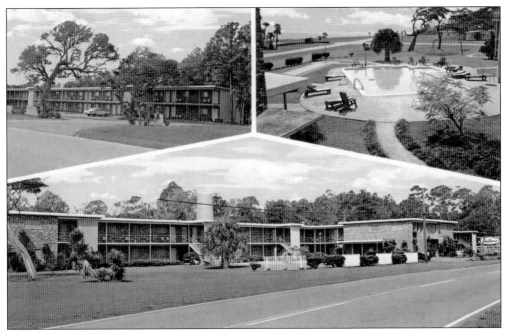

Opened in 1959 as a 21-unit building, the Seafarer Apartments were constructed using bricks from the recently demolished Oglethorpe Hotel in Brunswick. The name was soon changed to Seafarer Inn and Suites, which offered one- and two-bedroom kitchenettes.

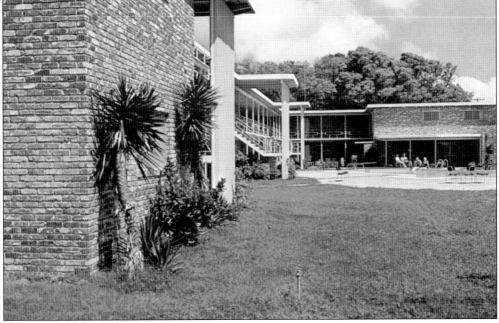

Located just across Beachview Drive from the Wanderer Motel, Seafarer Inn and Suites expanded in 1965 and again in 1971 to have a total of 71 rooms. By 1999, the motel was also known as Quality Inn and Suites, although it never officially dropped the Seafarer name.

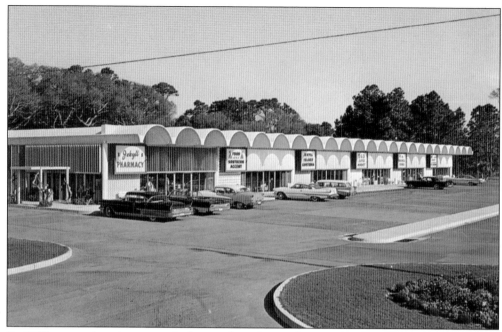

By 1959, a new shopping center had opened on the northwest side of the Jekyll Island Parkway and Beachview Drive intersection. The center included a pharmacy, a cafeteria, a supermarket, a Maxwell's Variety Store, and a post office.

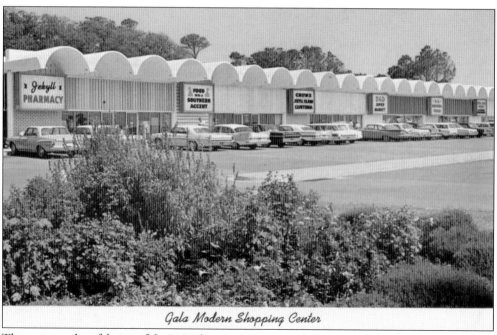

Gala Modern Shopping Center

The corrugated roof design of the 1959 shopping center was the same as on the new north and south bathhouses. In later years, the cafeteria closed, and a real estate office, gift shops, and a bank opened.

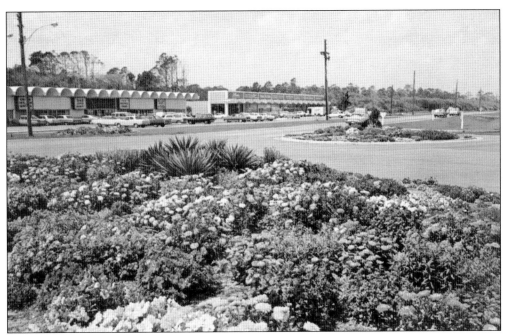

In 1964, the shopping center was expanded with an additional space just north of the original structure and sporting a completely different facade. The tenants of the new building included a gift shop, a couple of clothing stores, a restaurant, a 7-Eleven store, a realty office, and a coin laundry.

A breezeway between the two shopping centers was beautifully landscaped with palms and flowers. In the 1980s, a restroom building was added to this site. By the early 2010s, the businesses had either closed or were moved to a temporary location just south of Oceanside Inn and Suites, as both complexes were demolished to make way for the new Beach Village retail center.

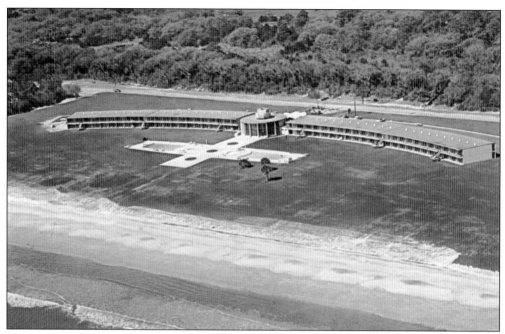

Opened in 1960, the Corsair Motel, named for the yacht of the financier J.P. Morgan, was the first motel constructed south of the entrance parkway. The building was located at the southern end of the boardwalk and sported double swimming pools and a restaurant with an unencumbered view of the Atlantic Ocean.

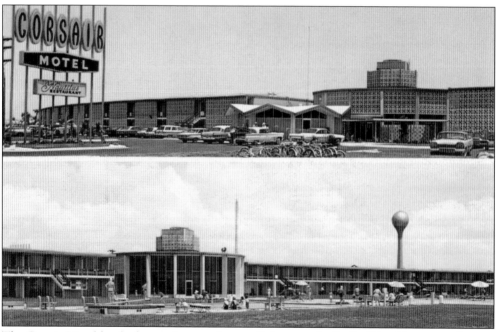

The Corsair Motel has had several name changes. It became the Ladha Island Inn around 1980, the Jekyll Inn and Resort in 1984, the Days Inn by 1986, and the Days Inn and Suites in 1999.

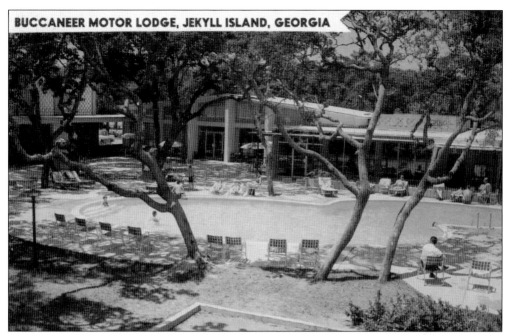

BUCCANEER MOTOR LODGE, JEKYLL ISLAND, GEORGIA

In 1961, Sam Snead's Buccaneer Motor Lodge opened just south of the Corsair Motel. Snead, a professional golfer, visited the island that year to play a round of golf and participate in a golf clinic to promote the motel. The sponsorship was dropped the next year, and the motel was renamed the Buccaneer Motor Lodge.

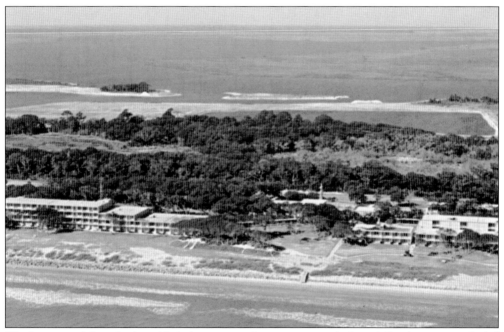

The Buccaneer Motor Lodge added a large wing of guest rooms in the late 1960s. Amenities included a restaurant, tennis courts, a courtyard swimming pool, and enough meeting space to accommodate small conventions.

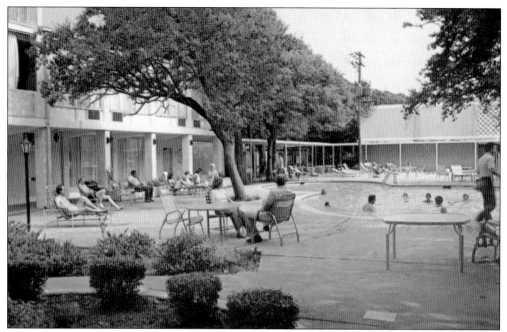

Name changes to the Buccaneer Motor Lodge include Quality Inn Buccaneer (in 1985), the Clarion Resort Buccaneer (in 1990), and the Buccaneer Beach resort (until it closed in the early 2000s). The building sat empty for several years before its demolition in 2007.

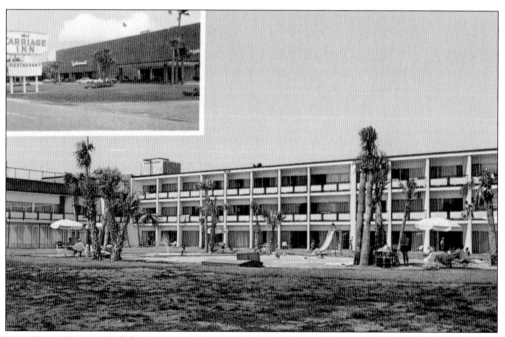

In 1961, a 106-room Holiday Inn opened just south of Sam Snead's Buccaneer Motor Lodge and north of the newly relocated South Dunes Picnic Area. This three-story motel featured a unique swimming pool shaped like the state of Georgia as well as a restaurant and meeting and convention facilities.

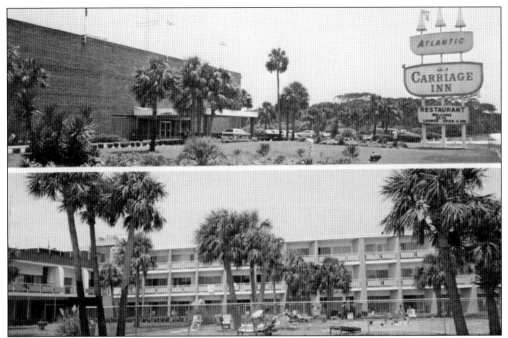

The Holiday Inn experienced numerous name changes. In 1963, it became the Stuckey's Carriage Inn, then the Atlantic Carriage Inn (in the 1970s), the Ramada Inn (in 1980), and the Georgia Coast Inn (until its closure in 2003). The building was demolished in 2005, and the site is currently occupied by a Courtyard/Residence Inn by Marriott.

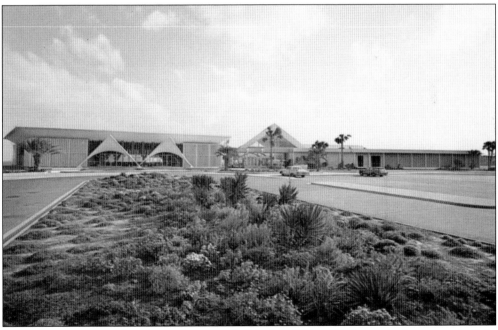

Located in a prominent location at the east end of the Jekyll Island Parkway, the Aquarama, built in 1961, was Jekyll Island's first convention center. The complex included a swimming pool, a ballroom with banquet facilities, and a 2,600-seat convention hall.

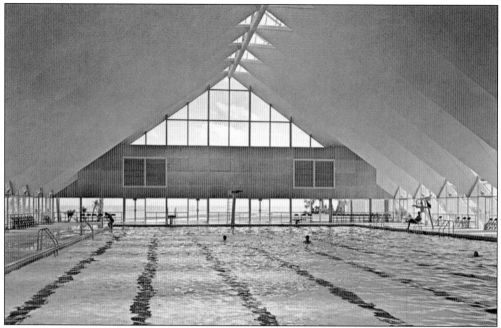

The centerpiece of this neo-futuristic building housed an Olympic-size heated swimming pool complete with one- and three-meter diving boards and a wading pool. It was later determined that the pool was a few meters short of Olympic standards.

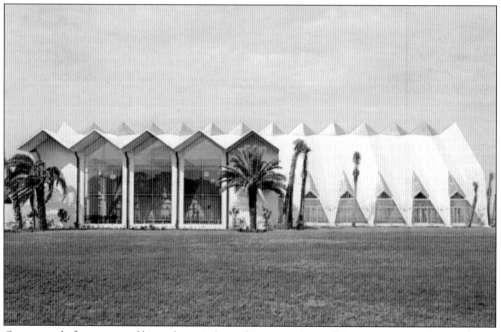

Constructed of concrete and large glass windows, this triangular-roofed structure created a greenhouse atmosphere and provided a comfortable swimming environment even in the most inclement weather. One author recalls the inside air being very warm and the water being quite chilly.

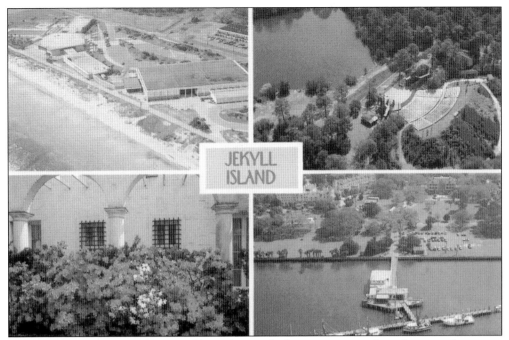

As the years went by, the chlorine and humidity inside the Aquarama pool area began to deteriorate the concrete roof buttresses. The building was eventually deemed unsafe, and the roof was removed in the early 1980s, giving rise to an outdoor pool (pictured in the upper left photograph on this postcard). The pool was demolished in the mid-1990s.

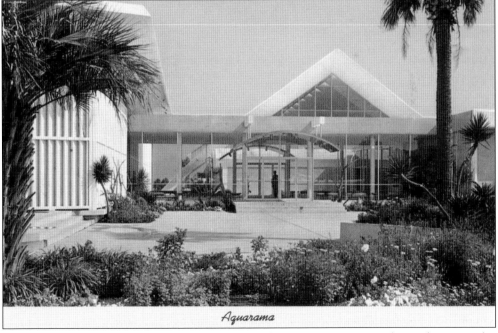

Aquarama

Although the Aquarama was originally designed to be a recreation center, the resulting complex became one of the top meeting facilities in the Southeast and was at the forefront of a long history of conventions on Jekyll Island.

In the early 1970s, the Aquarama was expanded with the addition of a new 2,250-seat convention center located on the north side of the existing facility. The concrete structure housed a large exhibit hall and meeting rooms.

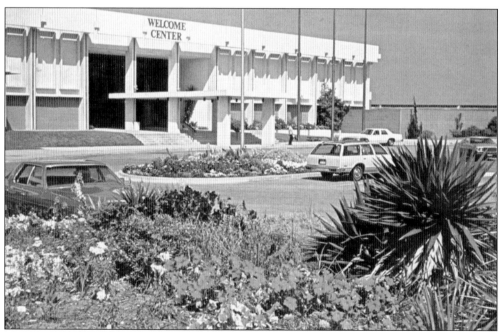

The Jekyll Island Welcome Center, originally located on the causeway just off the island, was relocated to an area just inside the Aquarama convention center building. The welcome center has since been moved to a new facility at its original location and renamed the Jekyll Island Guest Information Center.

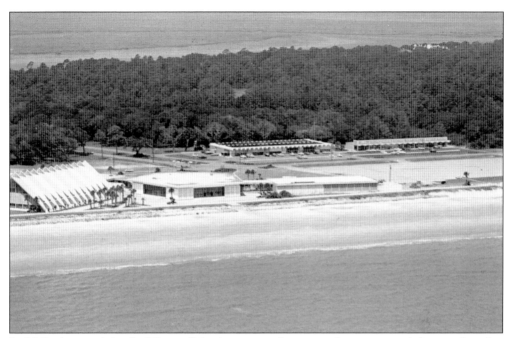

In 2010, the remaining buildings of the Aquarama, the convention center, and the two shopping center complexes were demolished and replaced with the new Jekyll Island Convention Center, the Beach Village, and a Westin Hotel.

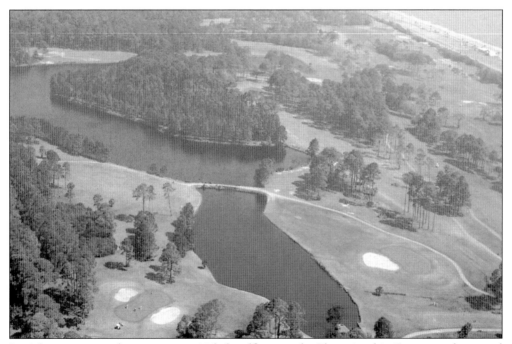

In 1961, construction began on a new 18-hole golf course, the Championship Course, on the general footprint of the 1910 golf course but with the addition of several new ponds. By 1962, nine holes were open for play, and three years later, all 18 holes were open while sharing the Great Dunes clubhouse.

A third golf course, the 18-hole Pine Lakes course, was carved out of the trees on the north side of Captain Wiley Road. This tight course opened in 1967 and was renovated to its present form in 2002.

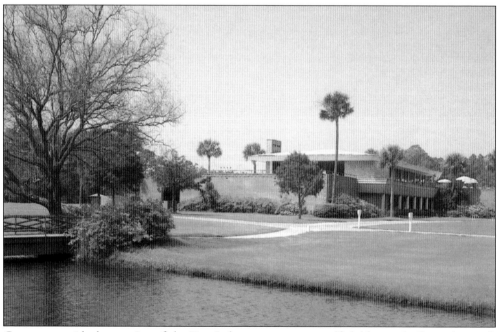

Concurrent with the opening of the Pine Lakes course, a new golf clubhouse, built on the south side of Captain Wiley Road, became the hub of golf operations on the island. The two-story facility served both the Pine Lakes course and the Championship Course, which had its holes renumbered to allow play to begin and end at the new clubhouse.

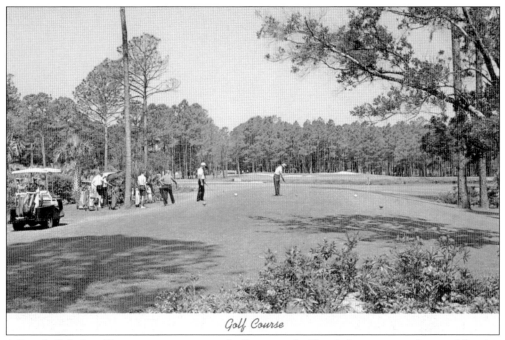

Golf Course

A fourth 18-hole golf course was constructed adjacent to the Pine Lakes course and opened for play in 1975. This new course was given the name Indian Mound due to the discovery of ancient shell middens on the site.

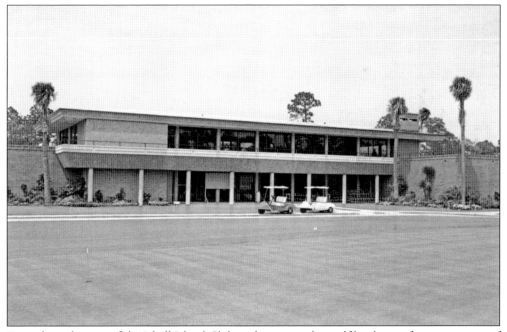

From the early years of the Jekyll Island Club to the present day, golf has been a favorite pastime of Jekyll Island residents and visitors. Although plans for alterations to the course layouts were being considered, at the time of this book's publication in 2023, there are currently three 18-hole courses and one 9-hole course.

The Jekyll Island Airport, located just north of the historic district and on the west side of Riverview Drive, was originally a grass airstrip that sat atop land that had once been part of the 1898 golf course. The airstrip was paved around 1965, and a service building was constructed. In 1967, the runway was extended to its current 3,715 feet. The remnants of a Confederate battery from the Civil War can be found hidden in the trees on the western side of the airstrip.

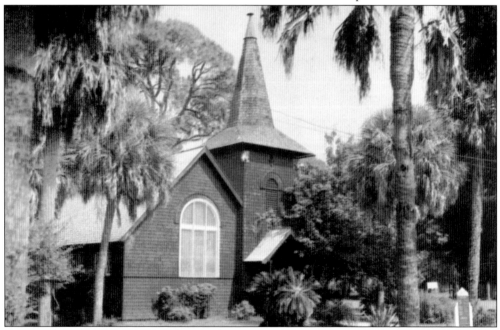

Prior to the early 1960s, the only house of worship on Jekyll Island was Faith Chapel. Although the chapel was used by several denominations, the building was inadequate to serve the growing population of residents and visitors on the island.

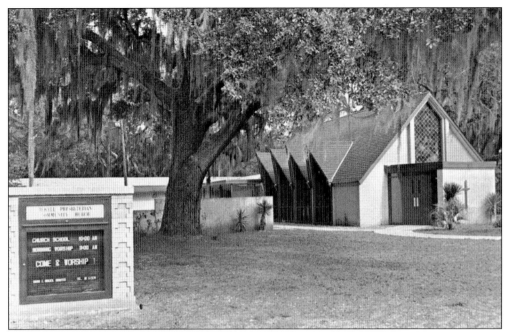

In the early 1960s, the Jekyll Island Authority set aside an area on the east side of Riverview Drive and across from the Jekyll Island Airport to be used for religious organizations. The first building, the Jekyll Presbyterian Community Church, was completed in 1962.

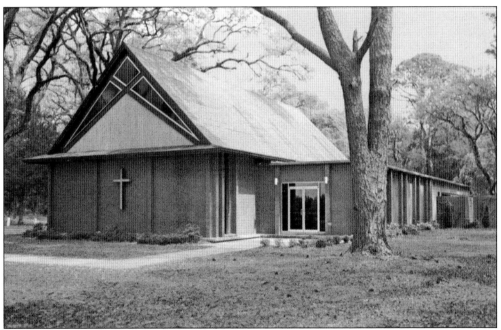

The Jekyll Island United Methodist Church opened in 1965. This building is shared with the congregations of St. Richard's Episcopal Church and Mission of St. Francis Xavier Catholic Church.

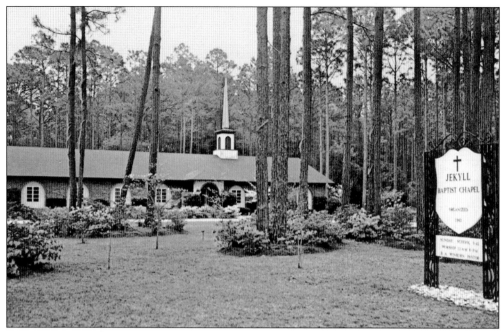

The Baptist congregation on Jekyll Island originally held services at Faith Chapel during the 1960s and early 1970s. The Jekyll Baptist Chapel, the latest house of worship constructed on the island, was completed in 1973 and is located between the Methodist church and the Presbyterian church on Riverview Drive.

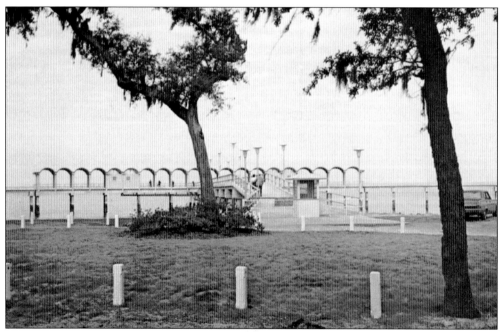

A popular spot for fishing and crabbing, the Jekyll Island fishing pier opened in 1969 at the north end of Jekyll Island at the Clam Creek Picnic Area. The architects incorporated a corrugated roof design as well as restrooms, a concession area, and a small booth at the entrance (for collecting a required fishing fee). The restrooms, concessions, and fishing fee have since been removed.

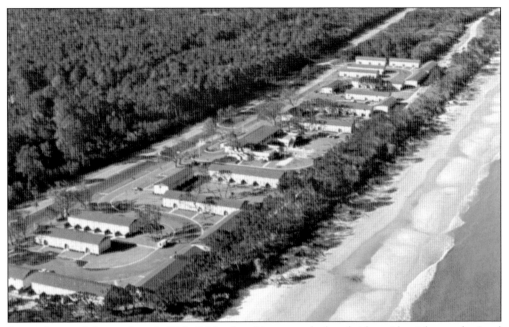

Located toward the north end of Jekyll Island and just past the beachside residential area, the Sand Dollar Hotel opened in 1971 and featured one-, two-, and three-bedroom townhouses. Amenities at this sprawling 263-room hotel included clubhouse facilities, a restaurant, and a swimming pool.

Like many of the other accommodations on Jekyll Island, the Sand Dollar Hotel experienced numerous name changes. It became the Jekyll Hilton Inn in 1987, the Best Western Jekyll Inn in 1992, the Jekyll Island Clarion Resort in 2008, and the Jekyll Oceanfront Resort before its closure in 2011. The buildings remained idle for several years before being demolished in 2015. The site is currently occupied by the Cottages of Jekyll Island.

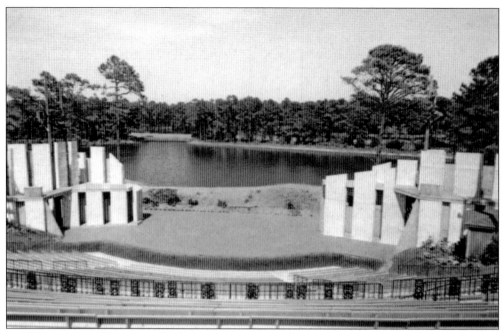

In 1972, a new 1,500-seat amphitheater was constructed in a quiet area just north of the historic district. *Drumbeats in Georgia*, a musical based on the history of the founding of Georgia under the leadership of Gen. James Oglethorpe, entertained audiences beginning in the summer of 1973. Several theatrical groups performed a variety of musicals at the venue until it was closed in 2004.

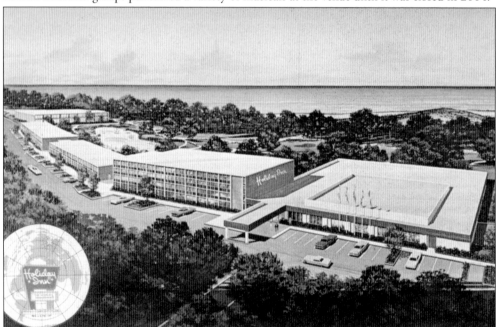

In 1975, a 205-room Holiday Inn was constructed on a site just south of the Atlantic Carriage Inn. The three-story structure was nestled behind the sand dunes, and the grounds were dotted with live oaks. A labyrinth of wooden boardwalks crossed the dunes and guided visitors to one of the most beautiful beaches on Jekyll Island.

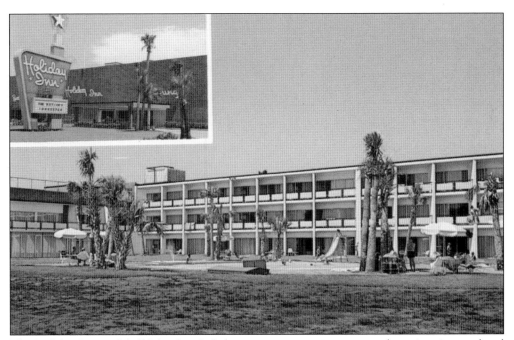

The Holiday Inn on Jekyll Island included a restaurant, tennis courts, and a swimming pool and conveyed a resort atmosphere due to its seclusion among the oaks, palms, and palmettos. Unlike most of the motels on the island, the Holiday Inn retained the same name until it was demolished in 2006. The property is currently home to the Hampton Inn and Suites and the Ocean Oaks residential community.

Opened in 1974, the By The Sea hotel was located on a large, wooded site adjacent to Driftwood Beach and featured 176 one-, two-, and three-bedroom units. A year later, it became the Sheraton By The Sea, and by 1981, it had become Villas By The Sea. The property was converted to privately owned condominiums in 1989.

Summer Waves, an 11-acre water park located on the southeast side of Jekyll Island, opened for business in 1988. Attractions at the park have been expanded over time and include multiple waterslides, a wave pool, a lazy river, and a water playground for the kids.

Since opening to the public in 1948, Jekyll Island has undergone a myriad of changes to its infrastructure. Shopping centers, convention centers, bridges, parks, restaurants, and other facilities have experienced the relentless cycle of construction, demolition, and reconstruction. There have been no fewer than 15 hotels erected on 13 different sites on the island. Through it all, Jekyll Island has retained the charm and beauty of its maritime forests, marshes, and unspoiled beaches.

BIBLIOGRAPHY

Bagwell, Tyler E. *Jekyll Island: A State Park*. Charleston, SC: Arcadia Publishing, 2001.

Bagwell, Tyler E., and the Jekyll Island Museum. *The Jekyll Island Club*. Charleston, SC: Arcadia Publishing, 1998.

Doms, Nick. *From Millionaires to Commoners*. Bloomington, IN: AuthorHouse, 2019.

Fleuren, Edward W., and Steven C. Baumann. *Golf Lover's Guide to Jekyll Island*. Jekyll Island, GA: Seascape Press, 2005.

Hutto, Richard Jay. *Their Gilded Cage: The Jekyll Island Club Members*. Macon, GA: Henchard Press Ltd., 2006.

McCash, June Hall. *The Jekyll Island Cottage Colony*. Athens: The University of Georgia Press, 1998.

McCash, June Hall, and Brenden Martin. *The Jekyll Island Club Hotel*. Virginia Beach: The Donning Company Publishers, 2012.

McCash, William Barton, and June Hall McCash. *The Jekyll Island Club, Southern Haven for America's Millionaires*. Athens: The University of Georgia Press, 1989.

Discover Thousands of Local History Books Featuring Millions of Vintage Images

Arcadia Publishing, the leading local history publisher in the United States, is committed to making history accessible and meaningful through publishing books that celebrate and preserve the heritage of America's people and places.

Find more books like this at
www.arcadiapublishing.com

Search for your hometown history, your old stomping grounds, and even your favorite sports team.